ANCIENT
ART

by Margaret Ellen Mayo

with the assistance of Heather S. Russell

Virginia Museum of Fine Arts

The publication of this book was made possible
by generous support from
The Council of the Virginia Museum of Fine Arts.

Library of Congress Cataloging-in-Publication Data
Virginia Museum of Fine Arts.
 Ancient Art: Virginia Museum of Fine Arts / by Margaret Ellen Mayo, with the
assistance of Heàther S. Russell
 p. cm.
 Includes bibliographical references and index.
 ISBN 0-917046-51-X
 1. Art, Ancient—Catalogs. 2. Art—Virginia—Richmond—Catalogs. 3. Virginia Museum
of Fine Arts—Catalogs. I. Mayo, Margaret Ellen, 1944– . II. Russell, Heather S. III. Title.
N5335.R53A54 1998
709'.01'074755451—dc21 98-8465
 CIP

ISBN 0-917046-51-X
Printed in the United States of America

Produced by the Office of Publications, Virginia Museum of Fine Arts, 2800 Grove Avenue,
 Richmond, Virginia 23221-2466 USA
Edited by Rosalie West; assisted by Susie Rikard
Series Editor: Monica Rumsey
Book Design by Jean Kane
Photography by Katherine Wetzel, Richmond, except as noted on page 92.
Composed by the designer in QuarkXpress. Typeset in Sabon, Franklin Gothic, and Albertus.
Printed on acid-free 80 lb. Warren Lustro Enamel Dull text by Progress Printing, Richmond,
 Virginia.
Binding by Bindagraphics Inc., Baltimore, Maryland.

Front cover: detail of *Senkamanisken, King of Kush*, 643–623 B.C., gray-black
granite, height 68 ⅞ inches (174.9 cm). See page 20.

Back cover: *Laconian Cup*, Greek, 545–535 B.C., terra-cotta; height 3 ¹³/₁₆ inches (9.7 cm).
See page 48.

Contents page: *Boat Model*, Egyptian, 1879–1801 B.C., wood coated with painted plaster;
length 28 inches (71.1 cm). Purchase, The Adolph D. and Wilkins C. Williams Fund, 53.30.3

Contents

Foreword

The Virginia Museum of Fine Arts is fortunate to have as the anchor of its permanent collection a rich array of art from the ancient world. Representation is particularly strong in the Mediterranean holdings, which include Egyptian, Near Eastern, Aegean, Greek, Etruscan, and Roman objects. These original works of art, like others in the museum's collection, belong to the people of Virginia and help to fulfill the museum's original mission to promote education in the arts throughout the Commonwealth.

Generations of Virginia school children from across the state have been especially drawn to ancient art because of its beauty and mystery, but also because of its human focus: the stories, myths, and religious practices that inspired many of these works emphasize struggles and achievements familiar to us all.

The quality and variety of the museum's collection of ancient art have also attracted the interest of the general public as well as scholars worldwide. Over the years many of our objects have reached ever wider audiences as loans to special exhibitions at other museums, both here and abroad. Other objects have been the impetus for loan exhibitions organized by the Virginia Museum staff and circulated to other U.S. museums: *The Art of South Italy: Vases from Magna Graecia* (1982–83) and *Early Cycladic Art in North American Collections* (1987–88).

Sources for building this distinctive collection have included the museum's two main endowments, The Adolph D. and Wilkins C. Williams Fund and The Arthur and Margaret Glasgow Fund. The museum has also received generous gifts of art, including 113 Cypriot vases donated by the Crawford Foundation in 1991. Most of the Classical and Egyptian art was purchased in the 1950s and 1960s, when the Trustees were guided by Director Leslie Cheek, Jr. (1948–68) and Chief Curator Pinkney L. Near (1954–90). They were fortunate to have as their advisors two distinguished experts, Christine Alexander for Greek and Roman art, and Bernard V. Bothmer for Egyptian art.

Since 1978 the ancient art collection has been in the care of its own curator, Dr. Margaret Ellen Mayo, who has contributed to its growth and made it more accessible to the public with new installations, publications, and lectures.

The museum's entire collection of ancient art was first published in 1973 with *Ancient Art in the Virginia Museum,* by Helen Scott Townsend Reed and Pinkney Near.

This book is the fifth in a series of collections handbooks that includes *African Art, Fabergé, Champion Animals: Sculptures by Herbert Haseltine,* and *Selections: Virginia Museum of Fine Arts.* We hope that *Ancient Art,* like its counterparts, will enrich the experience of viewing art at the Virginia Museum of Fine Arts and encourage many return visits.

Katharine C. Lee
Director
Virginia Museum of Fine Arts

Introduction

Curiosity is a powerful motivator. We wonder why our world is as it is; we wonder what the future holds; we wonder about the things left by those who lived before us. And most of all, we love a good story. Told and retold, stories have entertained us at the home fires and served as inspiration for art and literature for thousands of years. Yet if our love of visual expression had not been an equal partner to our narrative sense, would our world have been such an interesting place?

The material remains of ancient cultures are the basis of our knowledge about them. We must be mindful, however, that these remains have been preserved by chance while others have disappeared without a trace. Marble sculptures could be cut down and used as building blocks, and no one was the wiser. Bronze vessels or statues might be melted down and recast as another kind of object. On the other hand, Greek vases made of fired clay, once broken, had little further use, so their pieces have often been found discarded at the bottom of dry wells and later reconstructed. Many of the objects in this book were created for individuals and preserved in graves, where they were safe from looters and the elements. This in no way implies that ancient cultures were consumed with thoughts of death. As a matter of fact, because ancient religions hoped for life after death, tombs of the wealthy were stocked with provisions for the next life—dishes and utensils, tools, weapons, and jewelry, as well as sculpture and wall painting. From all these things, we can learn much about daily life as well as religion in the ancient world.

We must also remember that we see the ancient world through our modern eyes, and we must be aware that prejudices other than our own are also at work. Was Sparta really such a bad place in Greece during the fifth century B.C., or did Athenian historians "bend" the facts? What color prejudices, if any, did ancient cultures have? Are artists, artisans, or architects more technically sophisticated or more able today? Where we see beauty, did they?

Curiosity moves artists to create art, and our questions help us to understand it. This book is designed to answer questions about ancient art—and pose new ones—but also to promote the enjoyment that comes with looking at the art itself.

Margaret Ellen Mayo
Curator of Ancient Art
Virginia Museum of Fine Arts

Acknowledgments

This book is the result of the inspiration, generosity, and hard work of the staff of the Virginia Museum of Fine Arts, as well as the collectors, dealers, donors, and Trustees who have understood the importance of ancient art in our world today and supported the growth of the museum's collection. I am thankful to the Director, Katharine C. Lee, for her unflagging vision of the museum's handbook series.

The insightful work of Heather S. Russell, research assistant for this book, has been invaluable at every stage of the project. Rosalie West has been the best of editors as she constantly challenged us to see with fresh eyes. Katherine Wetzel's beautiful photographs and Jean Kane's thoughtful design have brought our words—and the objects—to life. Patricia Gilkison, former assistant curator in the Department of Ancient Art, was instrumental in selecting the objects and establishing the focus of the project. Sandra L. Higgins, intern for Ancient Art, was especially helpful on the Egyptian section. Valuable advice also came from Monica Rumsey, Sarah Lavicka, and Anne Barriault (Publications); Sandra Rusak (Education and Outreach); Kay Davidson, Arlene De Conti, Carol Dunham, and Kay Remick (Docents); and Phoebe Brooks (Museum Shop). Many other members of the museum staff also contributed to the production of this book: Suzanne Freeman, Eliza Knox, and Diana Dougherty (Library); Howell Perkins and Stephanie Thompson (Photographic Resources); Denise Lewis and Susie Rock (Photography); Lisa Hancock, Karen Daly, and Roy Thompson (Registration); and Mary Brogan, Martha Pittenger, and Rosalind Birdsall (Lighting).

I am grateful to the National Endowment for the Arts for a research grant that enabled me to begin work on this book, and to The Council of the Virginia Museum of Fine Arts for funding the publication of this book and many others about the museum's collections.

Special thanks are also due to William H. Peck, Curator of Ancient Art at the Detroit Institute of Arts, for his guidance on the Egyptian entries; and to Dietrich von Bothmer, Distinguished Research Curator at The Metropolitan Museum of Art, New York, for discussing Amazons on Etruscan vases with me. Particular thanks are due to the late Bernard V. Bothmer, consultant for the initial development of the Egyptian collection. As always, I am deeply grateful to the late Fordyce W. Mitchel and Arthur Dale Trendall for sharing their passion for the ancient world with me. —M.E.M.

ATLANTIC
OCEAN

ITALY

ETRURIA

ADRIATIC
SEA

Amphipoli
MACEDONIA

Rome

Naples

Boscotrecase

APULIA

Pompeii

GREECE

AEGEA
SEA

TYRRHENIAN
SEA

Delphi

Thebes
BOEOTIA

Corinth
CORINTHOS

Athen
ATTICA

SICILY

IONIAN
SEA

Mycenae

Sparta
LACONIA

Carthage

PELOPONNESUS

CYCLAD
ISLAN

CRE

MEDITERRANEAN SEA

AFRICA

Map of the Ancient World

■ This map shows the locations for the main cities
and regions named in this book, along with
many other historically significant places.

■ Please note that in ancient times, Greece was
composed of a number of city-states, each with
a capital city and surrounding area—for example,
Athens in Attica, Sparta in Laconia.

■ City-states and other ancient regions are shown
in italic type and in all capital letters.

BLACK SEA

Constantinople

roy

ASIA MINOR

CASPIAN
SEA

LAKE
URMIA

PHRYGIA

ASSYRIA

Nimrud

MESOPOTAMIA

RHODES

CYPRUS

PERSIA

Euphrates River

Tigris River

SYRIA

PHOENECIA

Babylon

JUDAEA

Alexandria

PERSIAN
GULF

Giza (burial grounds)

aqqara (burial grounds)

Memphis

FAIYUM

Amarna

ARABIA

EGYPT

Karnak

Thebes
(burial grounds)

Thebes
(city)

VALLEY OF
THE KINGS

Nile River

RED
SEA

↓ KUSH
(NUBIA)

| | 3000 | | 2500 | | 2000 | | 1500 |

EGYPTIAN

Predynastic Period	Archaic Period	Old Kingdom	First Intermediate	Middle Kingdom	Second Intermediate	New Kingdom
7000–3100 B.C.	3100–2700 B.C.	2700–2200 B.C.	2200–2040 B.C.	2040–1640 B.C.	1640–1550 B.C.	1550–1070 B.C.
	(Dynasties 1–2)	(Dynasties 3–6)	(Dynasties 7–10)	(Dynasties 11–13)	(Dynasties 14–17)	(Dynasties 18–20)

Pyramids built at Giza, 2575–2465 B.C.

Reign of Akhenaten, 1353–1335 B.C.
Reign of King Tutankhamun, 1333–1323 B.C.

NEAR EASTERN

Sumerian	Akkadian	Hittite	Babylonian
3300–1900 B.C.	2300–1000 B.C.	2000–1193 B.C.	4000–300 B.C.

Hammurabi rules in Babylon
1792–1750 B.C.

AEGEAN

Early Cycladic	Minoan Crete		Mycenaean
3200–2200 B.C.	3200–1470 B.C.		1575–1200 B.C.

Time Line of Ancient Civilizations

- This time line shows the main cultural, historical, and political periods and events for the ancient western civilizations represented in this book.

- In the color bars for Egyptian and Greek civilizations, the periods named represent distinct artistic styles and techniques that characterize those periods.

- Where cultures overlap within a bar, or exact dates are not known, the identifying names are placed near the midpoint of a given culture or period.

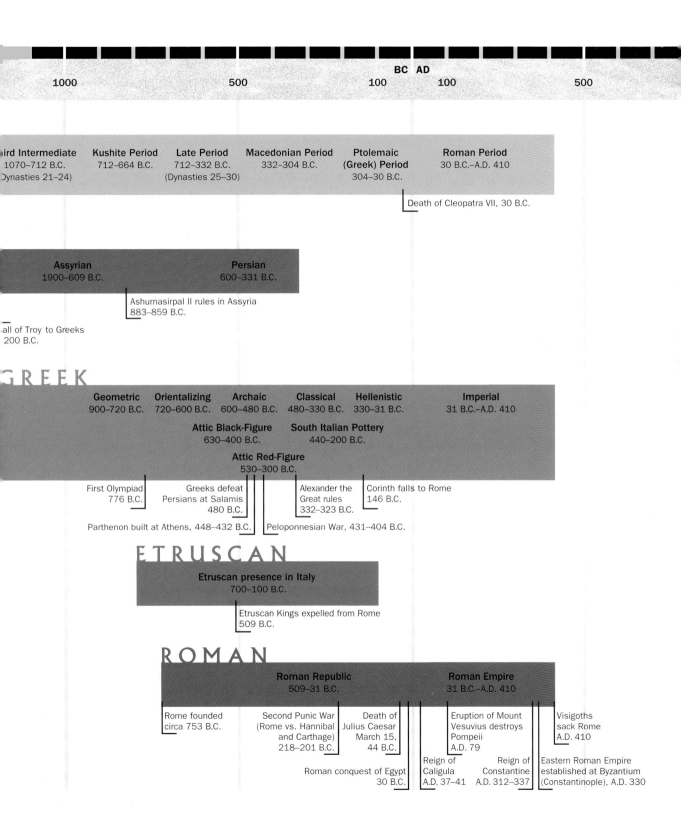

BC AD

1000 500 100 100 500

ird Intermediate | **Kushite Period** | **Late Period** | **Macedonian Period** | **Ptolemaic** | **Roman Period**
1070–712 B.C. | 712–664 B.C. | 712–332 B.C. | 332–304 B.C. | **(Greek) Period** | 30 B.C.–A.D. 410
ynasties 21–24) | | (Dynasties 25–30) | | 304–30 B.C. |

Death of Cleopatra VII, 30 B.C.

Assyrian
1900–609 B.C.

Persian
600–331 B.C.

Ashurnasirpal II rules in Assyria
883–859 B.C.

all of Troy to Greeks
200 B.C.

GREEK

Geometric | **Orientalizing** | **Archaic** | **Classical** | **Hellenistic** | **Imperial**
900–720 B.C. | 720–600 B.C. | 600–480 B.C. | 480–330 B.C. | 330–31 B.C. | 31 B.C.–A.D. 410

Attic Black-Figure | **South Italian Pottery**
630–400 B.C. | 440–200 B.C.

Attic Red-Figure
530–300 B.C.

First Olympiad
776 B.C.

Greeks defeat
Persians at Salamis
480 B.C.

Alexander the
Great rules
332–323 B.C.

Corinth falls to Rome
146 B.C.

Parthenon built at Athens, 448–432 B.C. Peloponnesian War, 431–404 B.C.

ETRUSCAN

Etruscan presence in Italy
700–100 B.C.

Etruscan Kings expelled from Rome
509 B.C.

ROMAN

Roman Republic
509–31 B.C.

Roman Empire
31 B.C.–A.D. 410

Rome founded
circa 753 B.C.

Second Punic War
(Rome vs. Hannibal
and Carthage)
218–201 B.C.

Death of
Julius Caesar
March 15,
44 B.C.

Eruption of Mount
Vesuvius destroys
Pompeii
A.D. 79

Visigoths
sack Rome
A.D. 410

Reign of
Caligula
A.D. 37–41

Reign of
Constantine
A.D. 312–337

Eastern Roman Empire
established at Byzantium
(Constantinople), A.D. 330

Roman conquest of Egypt
30 B.C.

EGYPTIAN ART

Ancient Egypt, one of the world's oldest civilizations, owed its existence to the world's longest river. Originating in the mountains of central Africa, the Nile flows northward some 4,000 miles to the Mediterranean Sea. Each year for thousands of years—before the Aswan High Dam was built in 1970—the Nile used to flood its banks, bringing water and nutrients to a narrow strip of land on either side. Vast stretches of the North African desert and mountain ranges lay beyond the river, naturally protecting those who lived along its shores from outsiders. Secure in their livelihood, the inhabitants of the Nile Valley developed a distinct and complex society more than five thousand years ago, and their history continued virtually unbroken for more than three thousand years.

With the unification of the kingdoms of Upper and Lower Egypt under King Menes around 2920 B.C., the Egyptians began to develop a highly structured society complete with taxes, organized religion, and sophisticated systems of mathematics and writing. The Egyptian historian Manetho, writing in Greek during the early third century B.C., measured the immense length of Egyptian history in thirty dynasties (families of rulers). Modern historians have further designated the great eras of Egyptian history as the Old, Middle, and New Kingdoms, which were separated by periods of political disunity. Our access to the civilization of ancient Egypt is mainly through the histories written by ancient Greeks and

Romans (who were as far removed in time from the beginnings of Egypt as we are from classical Greece), and from the discoveries of modern archaeology. Many of our words for things Egyptian are not Egyptian but Greek: "pyramid" comes from a Greek word for "cake," and "hieroglyph" is actually Greek for "sacred carving."

The ancient Egyptians' concepts of life and death affected every aspect of their culture. The goal of life was to live in harmony with the gods, and they believed that death was not an ending but the gateway to eternal life. The Egyptians believed in many major and minor deities, each influencing a particular aspect of human life. They considered their king the representative of the gods, and thus the necessary link between the gods and ordinary people. To ensure harmony between gods and humans into eternity, the Egyptians built huge temple complexes and put them under the control of powerful priesthoods. They also engraved thousands of prayers and recorded the deeds of their kings on the walls of temples. Members of the privileged classes, who could afford tombs, furnished them with necessities for the next life. Although most of our information about Egypt comes to us from these tombs, the message we receive from the ancient Egyptians is not about death, but about life and how it was lived, about power and splendor, joy and beauty.

Before Kings Ruled Egypt

From the earliest times, the Egyptians were master stone carvers.

Throughout Egypt's long history, artisans made vessels of stone as well as metal and fired clay. Among the most beautiful are those carved from extremely hard stone during the Predynastic Period, before Upper and Lower Egypt were united under one king, and before written records. The invention of the hand drill about this time meant that stone carvers could work more quickly than before, and it allowed them to produce a clarity of form and a crispness of detail not possible with other tools. Yet even with the use of a drill, the process of carving a vessel out of solid stone was expensive and time-consuming. A rise in the quantity of stone vessels dating from the Predynastic Period suggests that there was a growing upper class that could afford such luxuries (especially for their tombs),

as well as an increase in the number of specialized craftsmen capable of producing them.

This jar, with its thin, extended lip, gracefully curving body, and delicately rimmed base demonstrates the high level of technical and artistic skill among Egyptian sculptors. With a cord strung through the lugs on its shoulder, the jar could have been suspended, or the cord may have simply held a lid or cover in place. But we do not know what this jar held or whether it was ever used before being placed in the owner's tomb. The surface of the jar is smooth and undecorated by paint, its beauty depending on the sheen and pattern of the stone itself. The lack of adornment adds to the simplicity of form that makes this vessel so appealing.

Egyptian
Predynastic Period, 4000–3100 B.C.
Stone; height 7 1/16 inches (18 cm)
Purchase, The Arthur and Margaret Glasgow Fund, 84.72.

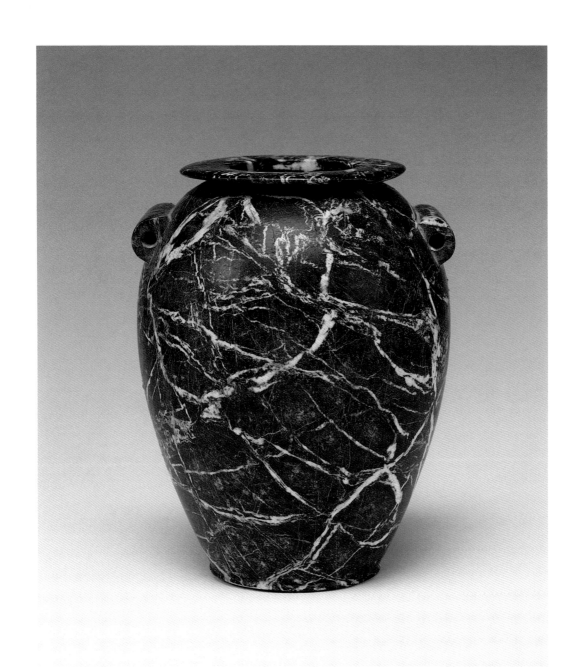

A Day in the Afterlife of a Wealthy Egyptian

A nobleman takes inventory of his possessions.

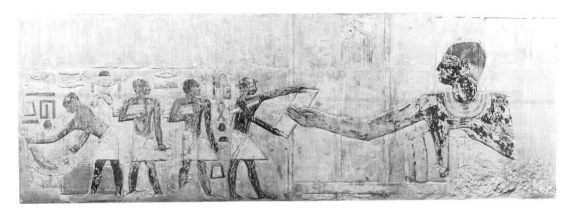

The Old Kingdom in Egypt (Dynasties 3–4, 2670–2195 B.C.) was the great age of pyramid building. The funerary cult was so important during this time that most statues and reliefs were made for tombs, funerary chapels, or other related structures. Many tomb reliefs show lively scenes of daily life, with images of the deceased often as individualized as actual portraits.

The strict order of social classes in ancient Egypt is clearly illustrated in this relief from the tomb of a nobleman named Methethy at Saqqara, a vast cemetery of the ancient capital of Memphis. By his large size, the nobleman is easily identified as the most important figure; his servants, who are taking inventory of his estate, are shown in smaller scale. A stately presence in his sedan chair, Methethy extends his massive arm toward the first servant, a scribe with pens tucked behind one ear and pen case under his arm. He has just unrolled a papyrus scroll for his master to review. Two more scribes wait their turn with scrolls under their arms. A fourth servant bends down to remove a magnificent necklace of beads from a large yellow chest.

This wall panel was delicately carved in low relief and enhanced with reddish brown, black, white, blue, green, and yellow paint, which made the scene more vivid when viewed within the tomb. The figures are posed according to conventions that were set hundreds of years earlier and lasted for two thousand more: the head and legs appear in profile, but the eyes and torso are seen from the front—except for the two servants on either end, whose bending and reaching actions give their torsos a more oblique view. The movements of these last two figures, together with Methethy's grand gesture, add to the sense of liveliness that the Egyptians wanted to preserve after death. Because writing was considered magical, the carved and painted hieroglyphs further ensure that Methethy would be properly served in the next life, even if the figures on the relief happened to be destroyed.

Egyptian
Old Kingdom, Dynasty 5, 2475–2345 B.C.
Limestone; height 19 1/16 inches (48.4 cm), length 55 9/16 inches (141 cm)
Purchase, The Adolph D. and Wilkins C. Williams Fund, 55.6.2

Right: Detail from Tomb Relief, *found at Memphis, Egypt.*

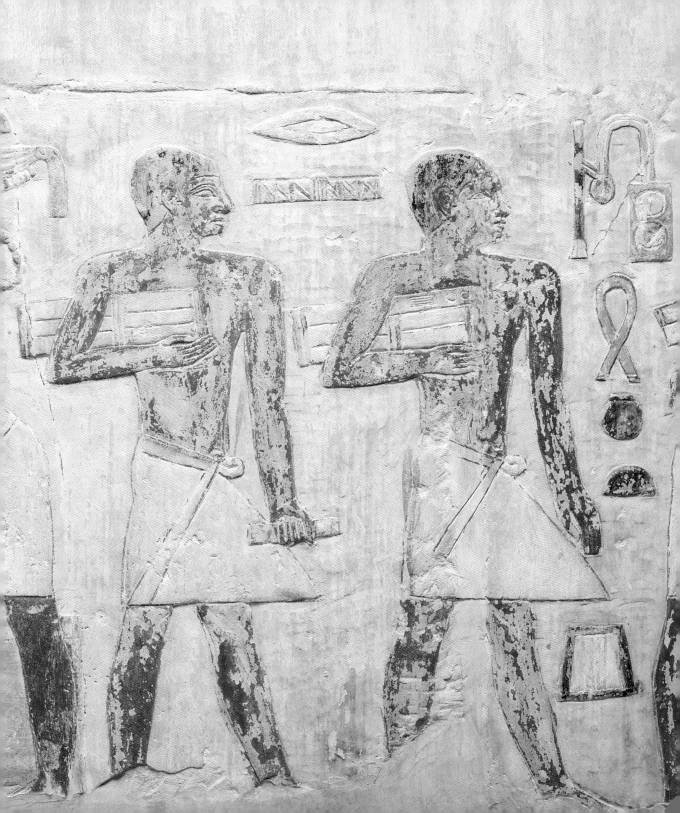

Awaiting Eternal Life

This masterpiece of Middle Kingdom sculpture was created for the tomb of a nobleman.

The vertical band of hieroglyphs decorating the edge of this figure's cloak is an invocation that begins, "An offering which the king gives to Osiris Khhentii-Imentiyw (Osiris, foremost of the Westerners), Lord of Abydos, that he may give the sweet breath of life to the Ka of the Commissioner of Police, Res, true of voice." With his cloak pulled securely around him, the statue's steady gaze and slight smile suggest the quiet confidence of one who expects his prayer to be fulfilled.

Following a period of political and social upheaval, Egypt was again united during the Middle Kingdom (Dynasties 11–13, 2040–1640 B.C.). Members of a powerful and growing upper class put many statues and reliefs of private individuals into public temples as well as their tombs, and art flourished again after a decline in the First Intermediate Period.

The sculptors of the Middle Kingdom were masters at carving very hard stones such as quartzite, which was usually reserved for figures of importance. The abstract form of this cloaked figure is especially well composed, with the placement of his arms echoing the fall of the wig over his shoulders and his diagonally posed hand offsetting the symmetry of his cloak. Sculptors of this period often carved the human figure in greater detail than their predecessors, but they also experimented with distorting natural forms. The head and hands of this sculpture are nicely detailed—high cheekbones and firm chin, delicately formed ears and precise fingernails—but they are also exaggerated in size compared with the rest of the figure. This sculpture, perhaps the most beautiful Egyptian statue in the Virginia Museum of Fine Arts, is a perfect example of the reserved, formal representations of individual citizens in Dynasty 12.

Egyptian, Middle Kingdom
Late Dynasty 12, circa 1785 B.C.
Brown quartzite; height 30 5/16 inches (76.9 cm)
Purchase, The Adolph D. and Wilkins C. Williams Fund, 65.10

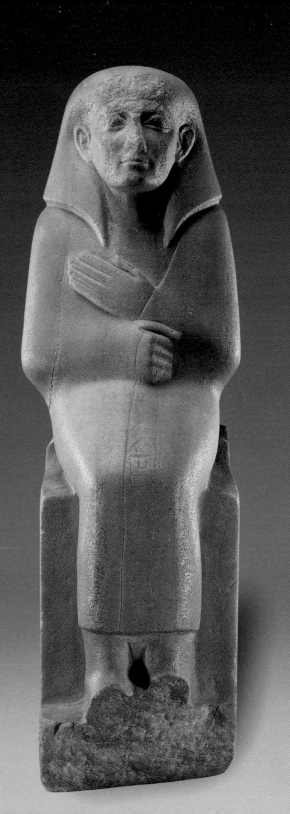

Protectress and Avenger

A lion's head symbolizes the dual character of a powerful goddess.

This lion's head once belonged to a larger-than-life statue of the goddess Sakhmet, protectress of Egypt and avenger for Re, the sun god and creator god. Sakhmet was often depicted by the Egyptians as a lion-headed woman to signify her fierce, unpredictable temper, which could bring death as easily as repel it.

In showing a god with animal features, the Egyptians were not worshipping an animal but rather illustrating certain characteristics of the god. Furthermore, their representations are not true to nature, but were created according to Egyptian artistic traditions—for example, Sakhmet's eyes are smaller in relation to her head than would be the case with a real lioness. Other conventional aspects of this image of Sakhmet are the royal uraeus (a cobra, symbol of sovereignty) placed between her lion's ears; the upright disk of the sun rising behind it (only partially intact here); the stylized mane, which frames the face like the sun's rays; and the long, straight wig that can be seen behind the mane.

King Amenhotep III commissioned hundreds of seated statues of Sakhmet —perhaps as many as seven hundred thirty—for the temples at Karnak, a large complex of holy precincts at the ancient capital, Thebes, in Upper Egypt. This head is probably from the Temple of Mut, the divine consort of the great god Amun. Originally it probably looked much like the nearly complete one shown to the left in a modern photograph taken at the precinct of the goddess Mut at Karnak. Even with Sakhmet's protection, Amenhotep could not have escaped death forever, but his obsessive desire to please her has left wonderful images for us to ponder.

Egyptian, New Kingdom
Dynasty 18, circa 1400 B.C.
Gray granite; height 20 3/16 inches (51.3 cm)
Purchase, The Adolph D. and Wilkins C. Williams Fund, 68.68

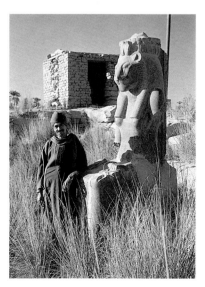

Nearly complete statue of the goddess Sakhmet at Karnak, Egypt.

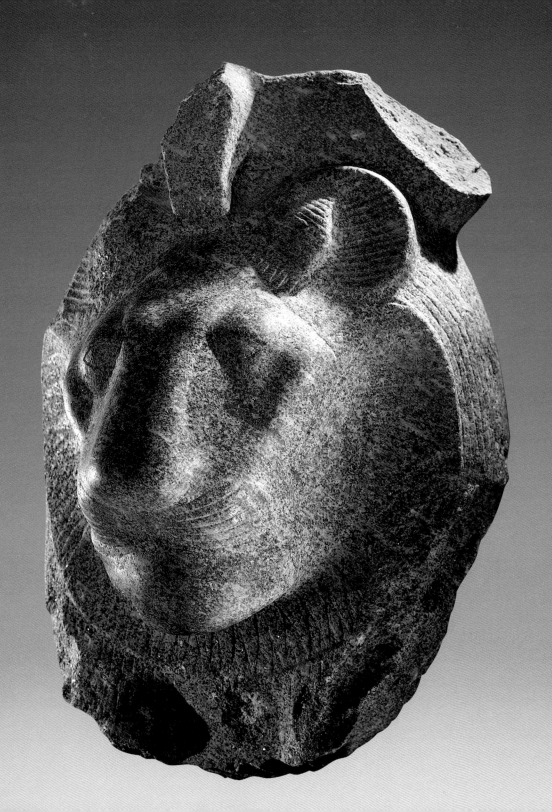

The Amarna Revolution

During the reign of Akhenaten, the time-honored conventions of Egyptian art were discarded in portraits of the royal family.

Though he ruled for only eighteen years (1353–1335 B.C.), King Amenhotep IV attempted to revolutionize Egyptian religion, politics, and art by abolishing the worship of all gods but one, the Aton, whose earthly manifestation was the sun. Changing his own name to Akhenaten (meaning "effective is the Aton"), he stripped power from the priests serving other gods and moved the political and religious capital of Egypt from Thebes to a new city named Akhtaten ("horizon of the sun-disk," modern Tel el-Amarna).

During this short period the traditional subjects and styles of Egyptian art changed significantly. Nature was shown more realistically, and the king and his family often appeared in intimate, affectionate scenes. Perhaps the most notable aspect of the art from this period is that the king, his wife Nefertiti, and their six daughters were portrayed with long, narrow heads and swollen bellies. These features, not usually seen elsewhere in Egyptian art, are evident in a detail from the relief of the royal family worshipping the Aton (near right). The scene appears on one of fourteen stone steles that marked the borders of the new city. Did Akhenaten and his relatives really look like this, or were the artists exaggerating their features for stylistic reasons? We do not know.

Princess with Sistrum allows us a closer look at one of Akhenaten's young daughters, probably Meritaten. She wears her hair in a side-lock typical for Egyptian children, and her sloping forehead, almond-shaped eyes, long nose, full lips, and prominent chin mark her as a member of the royal family. Meritaten's image was part of a large and complex scene, probably from the wall of a temple. The princess shakes a sistrum (a metal rattle used in religious ceremonies) and follows another figure, perhaps her mother, to the right.

Akhenaten's innovations were abandoned when he died: the seat of government returned to Thebes, and Egyptian artists returned to the conventional styles and subjects that had characterized Egyptian art for thousands of years. Tutankhamun, whose spectacular tomb was found in the Valley of the Kings by Howard Carter in 1922, was the second king after Akhenaten and the husband of one of Akhenaten's daughters. The discovery of Tutankhamun's tomb ignited an important revival of interest in Egyptian art and a significant trend in collecting Egyptian artifacts. Before long, elements of Egyptian styles could be seen in fashion, design, and architecture.

Egyptian, New Kingdom
Dynasty 18, 1353–1335 B.C.
Limestone; height 7 ½ inches (19 cm),
length 8 ¼ inches (20.9 cm)
Purchase, The Adolph D. and Wilkins C. Williams Fund, 63.20.3

Relief on a boundary marker still standing at Tel el-Amarna, Egypt.

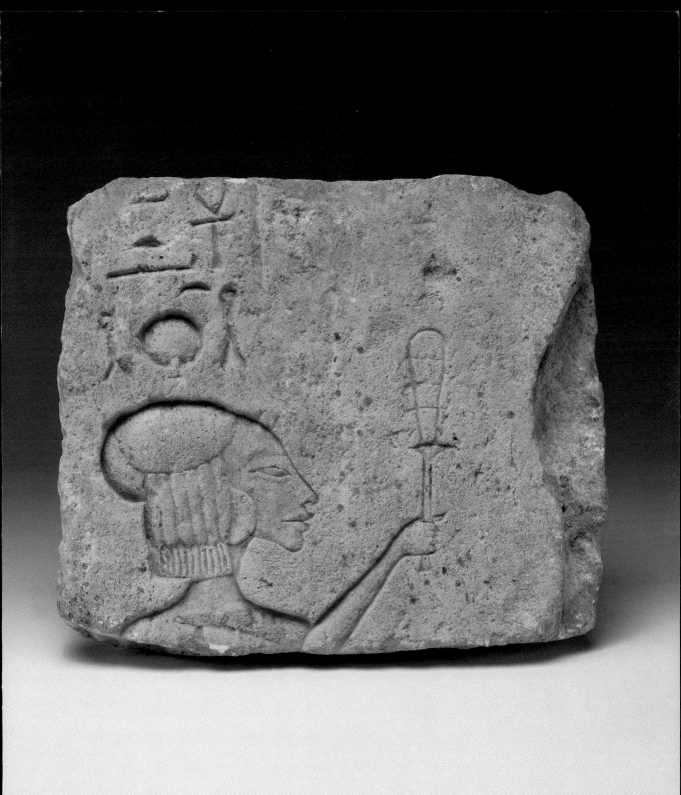

Dedication, Incantation, Resurrection

This rare papyrus fragment illustrates the journey of Osiris through the Underworld and the wish of a princess for eternal life.

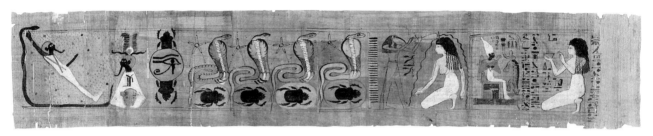

One of the great Egyptian inventions was a paperlike material made from the papyrus plant, which grew abundantly in marshlands. (The Greek word for the plant is "papyros," from which our "paper" takes its name.) The Egyptians removed the tough outer rind from the stalks and cut the inner pith into thin strips that were laid side by side in two layers at right angles to each other. When the papyrus had been pressed, dried, and burnished, it was durable and easily transported when rolled up. Used in Egypt since at least 3000 B.C., papyrus was exported to other Mediterranean lands, especially Greece and Rome.

This rare and beautiful painting is an extract of a religious text, the *Amduat*, a royal funerary document known as the *Book of That Which Is in the Underworld*. The focus of the *Amduat* was on the resurrection of the god Osiris and the reappearance of the sun each morning, both of which were models for the Egyptian hope of life after death. According

to myth, Osiris was killed and dismembered by his brother Seth, who was jealous that Osiris had been made king after the creation of the world. But Osiris's faithful wife, Isis, had collected the parts of his body so that Anubis, the god of embalming, could mummify him.

This section of the papyrus shows the rebirth of Osiris in the Underworld and his encounter with the kneeling Princess Henet-tawy, the deceased for whom this *Amduat* was made. On the left, we see the mummy of Osiris coming back to life. Facing him is Ptah-Sokar, a combination of two gods representing death and resurrection, wearing a headdress of horns, feathers, and the sun disk. The sun disk appears again with the wadjet eye (which has magical healing powers) and two scarab beetles; four more beetles with cobras follow, all symbols of rebirth. Their number stands for the four corners of the earth, and the stars in the background represent "praise." A vertical band

with horizontal stripes represents a door in the Underworld; on the other side of this door Thoth, the ibis-headed god of writing and scribe to Osiris, anoints the head of the kneeling Princess Henet-tawy in preparation for her meeting with Osiris, who is now Lord of the Underworld. As the princess makes offerings to him, surrounded by prayers on her behalf, Osiris is now seated on his throne wearing the white crown of Upper Egypt.

This scroll, said to have been found at Thebes, would have been part of a larger scroll, perhaps one that included a similar piece now in the British Museum, London.

Egyptian, Third Intermediate Period Dynasty 22, 945–718 B.C.
Tempera on papyrus; height 7 15/16 inches (20.2 cm), length 43 5/16 inches (110 cm)
Purchase, The Adolph D. and Wilkins C. Williams Fund, 54.10

Right: Detail from Mythological Papyrus *shows the rebirth of Osiris in the Underworld.*

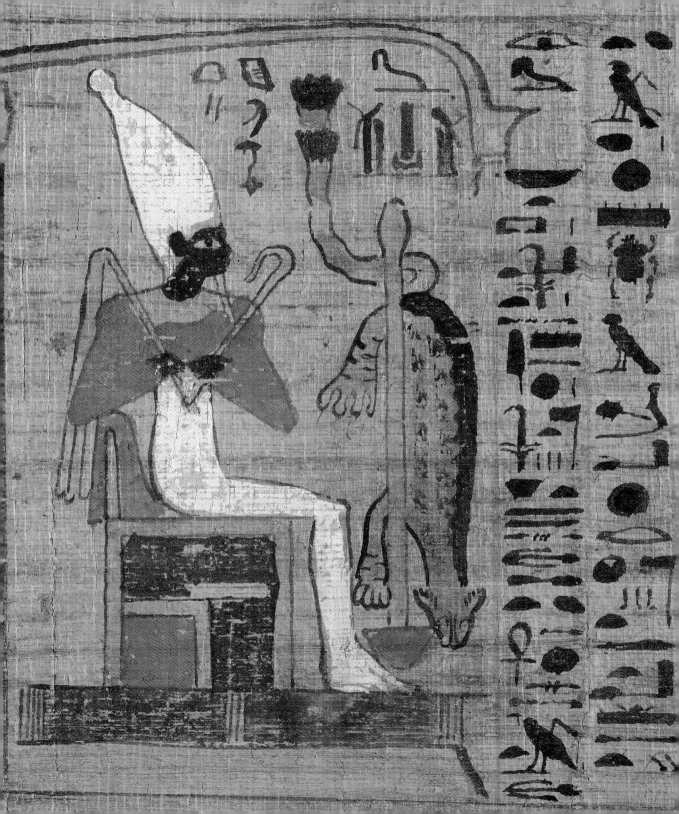

Art as Power and the Power of Art

This statue of a Kushite king reflects his grandeur—and the influence of Eyptian art on the art of other nations.

Between 712 and 664 B.C., during Egypt's Late Period, the country was ruled by invaders from the kingdom of Kush, south of Egypt. Founded in what is now Sudan during the first millenium B.C., Kush was the second oldest kingdom of Africa. The Kushites considered themselves the natural heirs to ancient Egyptian customs and traditions. They were especially impressed by Egyptian art and absorbed and adapted its conventions, visually asserting their claim as rulers. Even after they had been driven back into Kush, just before King Senkamanisken's reign, they continued to depict their kings in the Egyptian style.

In this stately statue, Senkamanisken appears considerably larger than life, a Kushite king dressed like ancient Egyptian royalty. Identified by the hieroglyphs on the supporting pillar at his back, the statue of Senkamanisken was found with others near the Great Temple of Amun at Gebel Barkal, in Sudan. Standing firmly with his left foot forward, his arms close to his sides, the king repeats a pose used for male figures in Egyptian art for thousands of years. Also typical of Egyptian sculpture are the solid areas behind his advanced leg and between his arms and torso, left

uncarved to ensure the statue's strength and durability, and the short staff or folded cloth in each fist, perhaps a sculptor's device to strengthen the carved hands. The gray-black granite from which the figure was carved must have made a striking contrast to the sheets of gold that

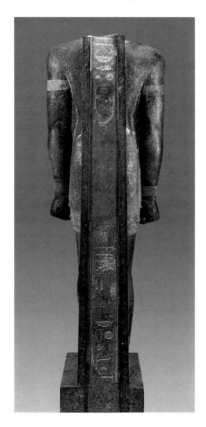

once covered the roughened surfaces of necklace, armlets, bracelets, kilt, and anklets. The head of the figure is lost, and the feet below the ankles and the base have been restored.

The Late Period, 712 to 332 B.C. (Dynasties 25–31), represents the last great era of Egyptian art. Although foreign powers controlled Egypt during much of this time, Late Period sculpture shows remarkably little external influence. Like the Kushites, other invaders—such as the Assyrians and Persians—so respected Egyptian culture that they made their own contributions in the Egyptian manner as well (and probably also gained authority by looking Egyptian). Renewal of interest in the art of sculpture appeared in the beginning of the Late Period, as it had centuries before in the opening years of the Middle and New Kingdoms. This time, however, non-Egyptian rulers —the Kushites—led the revival.

Kushite, 643–623 B.C.
Gray-black granite; height 68 7/8 inches (restored)
(174.9 cm)
Purchase, The Adolph D. and Wilkins C. Williams Fund, 53.30.2

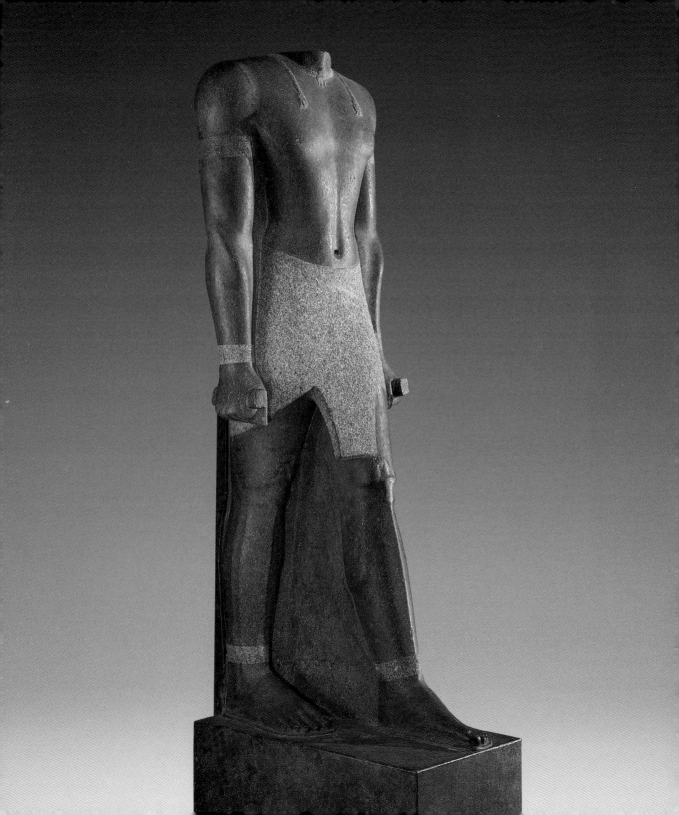

A Jovial Guardian

Any Egyptian mother would have cherished this image of the god Bes, to avert the anxieties of pregnancy, the pains of childbirth, and the perils of infancy.

This animal-headed dwarf represents Bes, the household god who guided women and children through the perils of pregnancy, childbirth, and infancy. It may be difficult to imagine turning to such a strange creature for help in times of distress, but to Egyptians, Bes's roundness and lionlike features symbolized abundance, power, and ferocity. As for his playful grin, diversion may have provided the best protection against pain and sorrow, which is perhaps why Bes was also associated with children's games and grown-up feasts.

One of the five or six best surviving examples of Bes-images in Egyptian art, this Bes is actually a jar made of faience, a ceramic-like material made from ground quartz that could be molded, carved, and then fired to achieve a glassy surface in various shades of blue and green. The missing lid would have been in the form of his tall, feathered headdress, and his fists (one is missing) would have held dippers or spoons to apply the contents. We know that when women were secluded during and after childbirth, they were cared for and pampered by special attendants until they could return to their normal activities in the household. This Bes may have held cosmetics or ointments for the mother, or perhaps medicine for a sick child.

Fully sculpted on all sides as a figure in the round, Bes squats on muscular legs, his belly supported by a narrow belt. His only other clothing (besides the missing head-dress) is a leopard skin, which has been split and carefully arranged around his neck so that the head and front legs hang down over his chest and the back legs and tail drape around his buttocks. The leopard's spots lend decorative pattern and texture to Bes's smooth torso, while his hairy head sports a neatly curled beard and tufted ears. But mostly we are drawn in by his laughter, which transforms his face, widening his mouth, nose, and eyes, raising his huge stylized eyebrows, and sending wrinkles across his cheeks and fore-head. During tribulations as well as celebrations, Bes would have been hard to resist.

Egyptian, Late Period
Dynasty 26, circa 600 B.C.
Faience; height 5 ⅝ inches (14.3 cm)
Purchase, The Adolph D. and Wilkins C. Williams Fund in Memory of Bernard V. Bothmer, 93.110

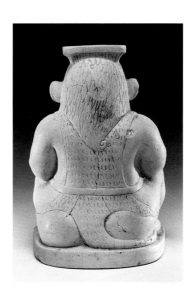

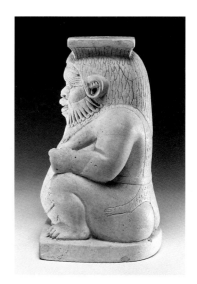

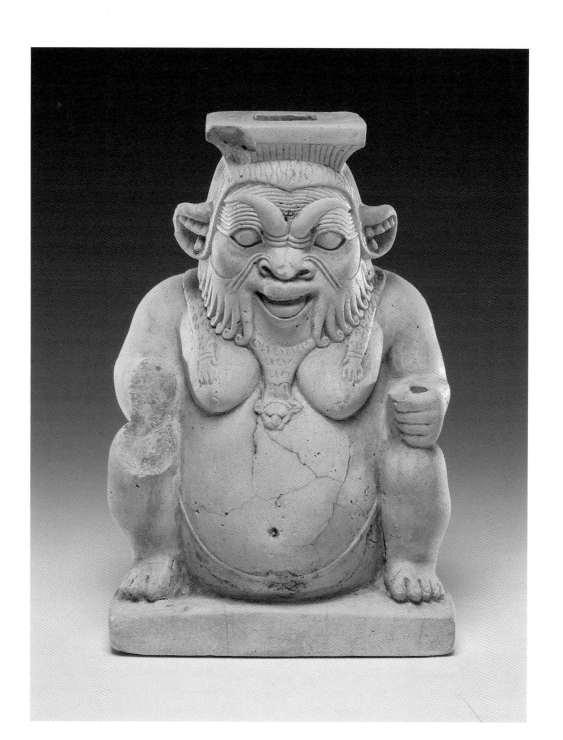

In the Right Vein

An Egyptian sculptor takes advantage of nature's artistry to produce a masterpiece.

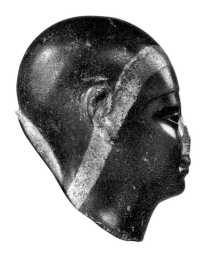

During the Late through Roman periods, Egyptian sculptors sometimes used stone with unusual veins and patterns. This beautifully carved male head was made from a piece of black granite with a rose-colored vein. The sculptor realized the dramatic impact of the vein, allowing it to run obliquely up the left side of the neck, across the brow, and down over the right ear. No amount of added decoration could surpass the striking, almost unsettling contrasts created by the stripe: its light pink color seen against the rest of the dark glossy surface; its lack of symmetry challenging the regularity of the man's features. At the same time, its curves echo the curves of the head, and harmony is restored.

As the body below the neck and most of the supporting pillar are missing, and no inscription survives, we can only assume that the person represented was wealthy and important enough to be able to afford such an expensive sculpture. A line in light relief across his forehead indicates that he is wearing a close-fitting cap; according to Egyptian custom, his head would have been shaved (men also wore wigs or left their heads bare). The elongated, egglike shape of the head is characteristic of Late Period sculpture, as is the smooth finish on the hard stone from which it was made. In the Old Kingdom, hard stones such as granite were usually reserved for statues of royalty.

Egyptian
Perhaps Macedonian Period (332–304 B.C.)
Granite; height 9 ¾ inches (24.8 cm)
Purchase, The Arthur and Margaret Glasgow Fund, 69.51

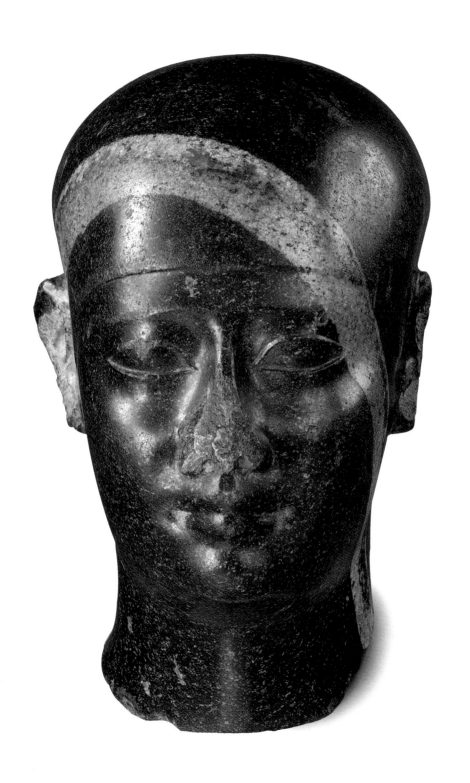

Kings Paying Tribute

By making offerings to the gods, kings validated their own rule.

This masterpiece of modelling and fine detail is an example of "sunk" relief in which the figures are carved into the surface more deeply than the background. Sunk relief was especially appropriate for the outside walls of buildings, where the sunlight could make the images visible at a distance. This example may have been part of a wall of the Temple of Isis at Behbeit el Higara, located in the center of the Nile Delta.

This portion of the relief has survived in three panels. In the middle section, which is the most complete, a king (identified by his royal uraeus headdress) offers incense to a falcon-headed deity on a throne, perhaps the moon god Montu, who holds a scepter in one hand and the *ankh*, a symbol of life, in the other. The inscription to the right of the king reads "burning incense for his father," but the name of the king in the cartouche above and to the right of his head has been erased. The partial panels to the left and right may have had similar scenes. In the left panel the seated deity is a goddess wearing a crown of cobras and cow horns with another cobra (uraeus) projecting from her forehead. She might be either Hathor, a fertility goddess, or Osiris's wife, Isis, who often wore Hathor's cow horns. In the right panel a king wears the crown of Lower Egypt.

Some details of this relief, such as the slight smile seen in all three human figures, the modelling of the male torsos, and the strongly projecting female breast, are characteristic of both the Late Period (Dynasty 30) and the Ptolemaic Period, thus suggesting a date in the fourth or third century B.C.

Egyptian, Late Period (Dynasty 30)–Ptolemaic Period, 304–30 B.C.

Red granite; height 34 ¼ inches (86.9 cm), length 63 ½ inches (161.2 cm)
Purchase, The Adolph D. and Wilkins C. Williams Fund, 63.45

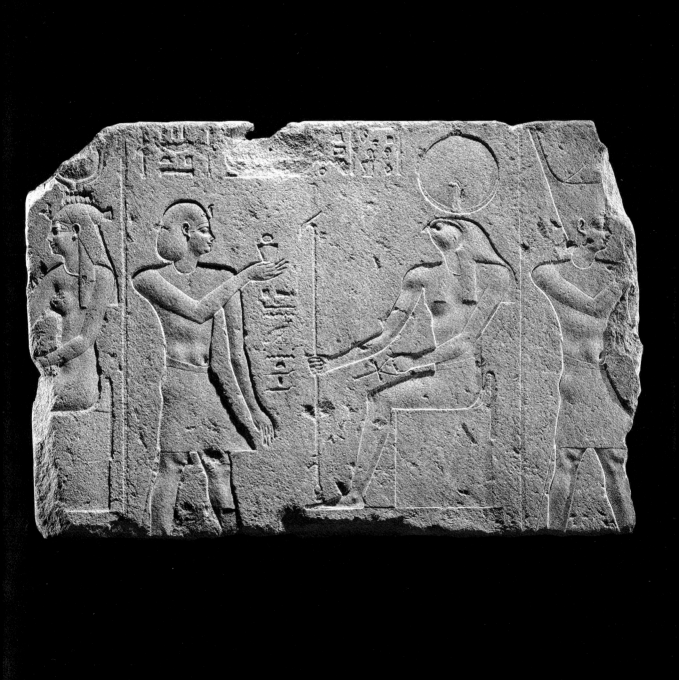

Maiden, Mother, or Minstrel?

This sculpture of a beautiful Egyptian woman depicts her in a striding stance unusual for the statue of a woman.

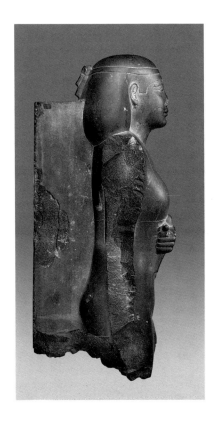

Images of private women are rare in Egyptian art. Since virtually no sculpture was made for the tomb during the Macedonian period—from Alexander's conquest in 332 B.C. until the reign of the first Ptolemy in 304 B.C.—this figure was probably designed to be in a temple; yet temples were the usual domain of gods, royalty, and the nobility. Furthermore, she stands with her left leg advanced like male figures throughout the long history of Egyptian free-standing sculpture. Women—goddesses, queens, wives—usually stood with legs together.

Other aspects of this statue are more in keeping with Egyptian sculptural traditions. Her voluptuous body is characteristic of Egyptian art during the Macedonian and Ptolemaic periods; her tight-fitting halter dress reveals curves but maintains modesty by concealing anatomical details. Such clinging clothing was purely an artistic invention, because in reality it would have prevented almost all movement. This woman's only accessories are the hair ribbon tied at the back of her large wig and the kerchief she holds to her breast.

Among other striding female figures with one or more similar details (wig with hair ribbon, handkerchief, hand to chest), the most intriguing parallels to this statue are those with inscriptions that identify them as singers or musicians. The pillar at the back of this figure bears no inscription, however, so her status in Egyptian society remains a mystery.

Egyptian
Macedonian Period, 332–304 B.C.
Schist; height 22 15/16 inches (58.2 cm)
Purchase, The Adolph D. and Wilkins C. Williams Fund, 55.8.13

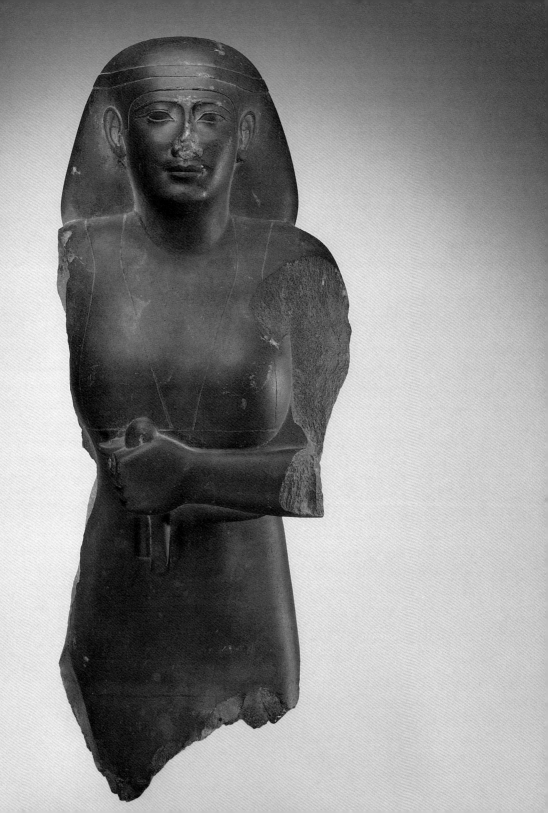

NEAR EASTERN ART

The area we call the Ancient Near East included vast expanses of land stretching from modern Turkey to the mountains of India, and from Armenia to Egypt. Many cultures flourished there, one of them perhaps the oldest on earth: that of the Sumerians in Mesopotamia, "the land between the rivers" (the Tigris and Euphrates in modern-day Iraq). By 3500 B.C. the Sumerians had invented the wheel, developed a method of irrigation to make their food supply less vulnerable to drought, built the first cities, and devised the first system of writing.

Unlike the Egyptians, whose settlements along the Nile were well protected from invaders by wide stretches of desert and rocky land, the people of the Ancient Near East had few natural barriers, and they forged their cultures in an atmosphere of almost constant warfare. Military strength was all-important, with absolute authority usually in the hands of a king who was considered the earthly representative

of a god. Politics and religion were thus closely allied, and royal activities such as processions, religious rites, and battles were the main focus of decoration in public places and inside the king's palace. The terrifying creatures—griffins, sphinxes, gorgons, winged monsters—appearing in Near Eastern art were witness to the belief that the gods would punish humankind for their transgressions.

The absence of natural barriers in this region encouraged trade as well as war, and trade routes extended eastward to China and westward through Greece and Italy to the Baltic Sea. As one Near Eastern culture succeeded another in dominance—Sumerians, Akkadians, Babylonians, Hittites, Assyrians, and Persians—they developed their own languages, religions, and artistic styles and enlivened other cultures to the east and west, especially those of the Egyptians, Greeks, and Romans.

A Familiar Scene with an Unexpected Twist

Among animals and arrows, a woman joins the hunt.

This hand-formed jar was found in northwest Iran near Lake Urmia, an area excavated by British archaeologists from 1968 to 1978. The pottery they discovered there is typically decorated with vibrant geometric designs and, occasionally, figures of humans and/or animals.

The geometric designs on this vase serve to frame and divide the complex and highly unusual narrative scenes. On one side, a male hunter (painted dark brown) has shot arrows at three animals that are escaping with one of their young following close behind (see below). On the other side, a woman (painted orange-red)

extends her arms toward the two dark (now faded) figures flanking her. This time, both manes and arrows are flying as the animals try to flee. Though larger than their human adversaries, the animals have no defense except swiftness against the hunters and their weapons. Throughout both scenes, long-necked waterfowl either flutter or stand in rows, reflecting the painter's desire to suggest a marsh setting—and to cover the entire jar with decoration.

While both of these scenes record the skill of hunters in providing food, they also attest to the power of humankind over the forces of nature.

The presence of a woman among hunters is rare, but not unknown, in ancient art. This scene may simply depict a family hunting together, similar to those found in Egyptian tomb paintings produced around the same time.

Near Eastern, from northwest Iran circa 1600 B.C.

Terra-cotta with polychrome decoration; height 9 $^{15}/_{16}$ inches (25.2 cm)
Purchase, The Arthur and Margaret Glasgow Fund, 86.118

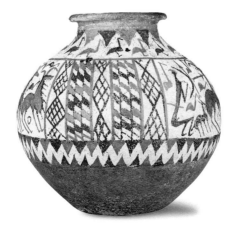
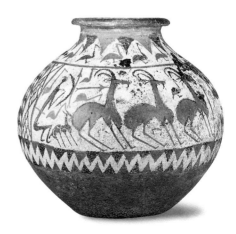

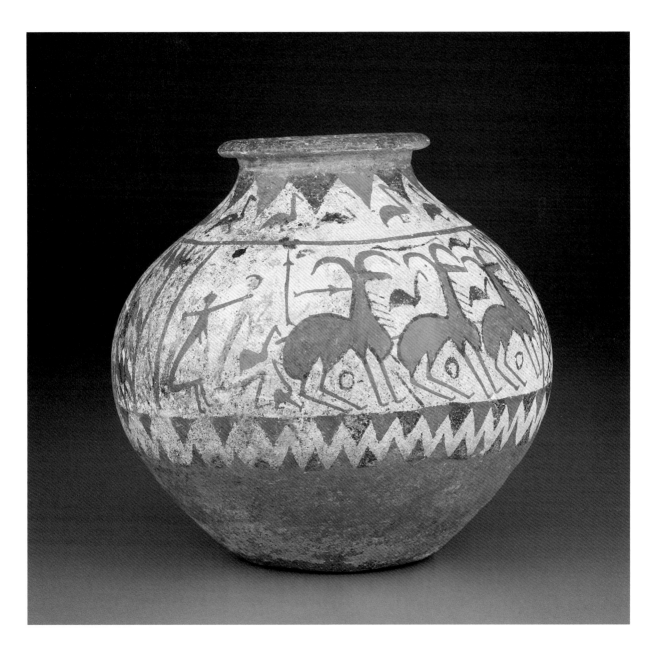

A Powerful Spirit to Protect a Powerful King

This relief of a divine spirit was carved on a palace wall to protect the king, while the inscription records his successes.

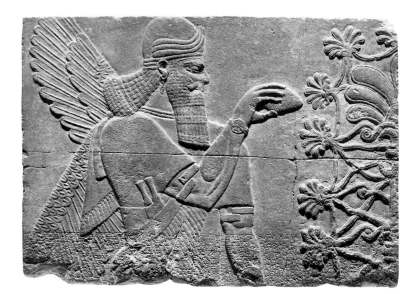

In the twelfth century B.C. the Assyrians succeeded the Babylonians and Hittites as the most powerful people in Mesopotamia, and by the early ninth century they were feared throughout the Near East. With conquest came wealth, and in 879 B.C. King Ashurnasirpal II chose a site on the Tigris River for his capital, Nimrud. The most splendid building in this new city was the royal palace, its walls lined with brightly painted stone reliefs celebrating the king's successes and honoring the gods.

This palace relief, which was near the throne room, shows a divine protector spirit, possibly in the ritual act of fertilizing a sacred tree (which may represent the Mesopotamian state). The elaborate patterns on his wings, hair, and beard complement the richness of his clothing and jewelry. His horned cap is a symbol of divinity; the tassels on his shawl are similar to those worn by royalty. But his double-handled dagger and great muscled arm were perhaps the most reassuring signs of his power to protect the king.

A cuneiform inscription across the lower part of the figure praises the king and his deeds and effectively prevents a successor from using the panel for his own glory. None of the original bright paint remains on this relief, but traces can be detected on other reliefs from the same palace, now in The Metropolitan Museum of Art, New York.

Assyrian, from Nimrud, in modern Iraq 883–859 B.C.

Gypseous alabaster; height 45 ⅛ inches (114.6 cm)
Purchase, The Adolph D. and Wilkins C. Williams Fund, 56.22

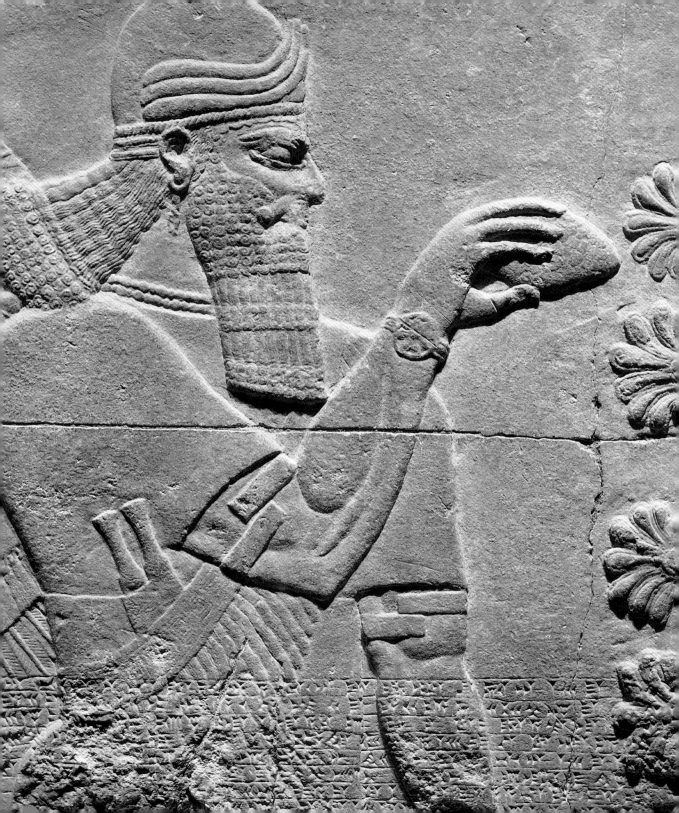

AEGEAN ART

The Aegean Sea, bounded by Greece on the west and Turkey on the east, was home and pathway for some of the most ancient cultures of the Mediterranean area. Between 3200 and 2200 B.C. a non-Greek culture flourished in the Cyclades, a group of more than thirty islands roughly forming a circle in the southern Aegean. Although the people who inhabited these rocky islands left no evidence of a written language or an organized society, their exquisitely carved marble figures and their vessels of marble, terra-cotta, silver, and gold are evidence of a long and sophisticated artistic tradition.

From about 3500 to 1400 B.C. a vibrant civilization also existed on Crete and eventually dominated the other Aegean islands. After discovering the remains of several great palaces with mazelike floor plans at Knossos, Malia, and Phaistos, archaeologists called the people of Crete Minoans after the mythological King Minos, who built a labyrinth at his palace on the island.

The Minoans were such a strong sea power that at the height of their civilization they did not feel the need to fortify their palaces, and such a strong economic power that they could afford such luxury goods as ivory and gold from Africa. (Their pottery has been found throughout the Aegean and in lands beyond, a sign of their extensive trade). Minoan records were inscribed in Linear A, a pre-alphabetic

script that has not yet been deciphered. The art of the Minoans—with its focus on sea and land creatures, plants and flowers, and religious ceremonies—reflects their peaceful existence and love of nature.

Succeeding the Minoans in control of the Aegean area were the Mycenaeans, named in modern times for Mycenae, reputed home of the Trojan War hero King Agamemnon. Their culture, centered on mainland Greece, flourished during the Late Bronze Age, from the fifteenth through the thirteenth centuries B.C. Like the Minoans, the Mycenaeans were seafarers who traded widely (their pottery has also been found throughout the Mediterranean), but in contrast to their island neighbors they fortified their palaces against each other and invaders from the sea. Perhaps reflecting their more uncertain existence, Mycenaean art is often preoccupied with military and religious themes. The Mycenaeans built elaborate palaces, fortifications, and tombs at Mycenae and other mainland sites (Pylos, Tiryns, and Thebes). They kept records in a pre-alphabetic script called Linear B, an early form of Greek that has been deciphered. Around 1200 B.C. it appears that a series of natural, economic, and/or political disasters struck mainland Greece, resulting in the destruction and abandonment of Mycenaean cities and bringing the Late Bronze Age to an abrupt and mysterious close.

Subtlety of Form, Clarity of Line

Mysterious figures and vessels from the Aegean islands keep their secrets well, revealing only their beauty.

Side view of Female Figure

This elegant *Female Figure* came from a grave on one of the Cycladic islands. Although these islands were essentially mountains of marble rising from the bed of the Aegean Sea, objects made of marble were relatively rare in burials during the Early Cycladic culture (3200–2200 B.C.), and most of these were containers. Human figures were made for a privileged few, but what they meant to their owners is a mystery. Most of the figures are female and have folded arms, slightly bent knees, and pointed toes as though they were meant to be reclining. (Male figures, and figures in other poses—playing harps, drinking, one standing on the shoulders of another— occurred even more rarely.)

The sculptor who carved this piece delighted in the interplay of curve and volume, using the line of the pubic triangle to emphasize the slightly swelling (pregnant?) belly and offset the graceful line of the shoulders. The liveliness of this figure is further enhanced by its irregularities— uneven nose, asymmetrical breasts, and legs of different length and width. Cycladic figures were often painted, but only traces remain here: a curved blue-black line for hair above the forehead (blue may also have been used for the eyes), red "tattoos" on the cheeks and nose (no mouth is

indicated), and red lines between the breasts (perhaps jewelry). The dark perpendicular mark on the belly may be unintentional.

Marble Cycladic vessels were produced in far greater numbers than the figures but share their austere beauty. Although the *Beaker* shown below was probably too heavy for everyday use, its shape is based on an ordinary drinking vessel. The elongated profile is repeated in the two handles, which have holes suggesting that such beakers could have been carried or suspended by cords.

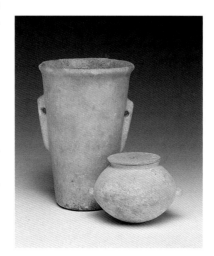

The little *Pyxis* ("box" in Greek) may have seen more regular use as a container for cosmetics, its comfortable curves making it as pleasing to hold in the hand as to behold with the eye. Yet without a flat bottom it must also have spent time suspended, its lid secured by a cord strung through holes in the lid and lip. Like the beaker, the pyxis may have been used in rituals before joining its owner in the grave.

Female Figure
Early Cycladic II, Late Spedos Variety
(or Late Spedos/Dokathismata Variety)
circa 2400 B.C.

Marble; height 14 ¾ inches (37.5 cm)
Purchase, The Adolph D. and Wilkins C. Williams Fund, 83.73

Beaker
Early Cycladic I, 3000–2800 B.C.

Marble; height 6 ³/₁₆ inches (15.8 cm)
Purchase, The Arthur and Margaret Glasgow Fund, 85.1546

Pyxis with Lid
Early Cycladic II, 2700–2200 B.C.

Marble; height with lid 2 ⅝ inches (6.7 cm)
Purchase, The Arthur and Margaret Glasgow Fund, 86.125 a/b

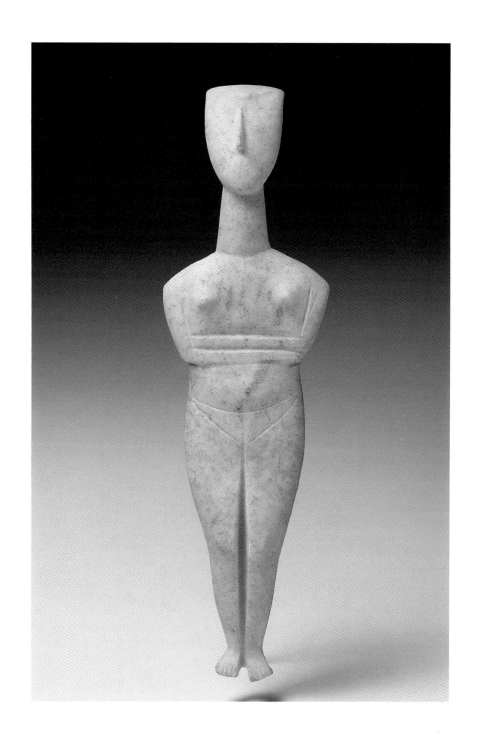

Iconography and Influence

An octopus and three handles tell a story of cultural connections across the Mediterranean.

One of the greatest legacies of the Mycenaeans is their pottery. Mycenaean vessels are both technically advanced and artistically appealing, with elegant wheel-made shapes and surfaces decorated with glazes of dark orange, brown, or red on a creamy background. Because they used their pottery for religious activities and trade as well as in their own homes, the Mycenaeans created a wonderful variety of vessels, from enormous amphorae to store and transport wine, grain, and olive oil to delicate drinking cups.

The Mycenaeans were less likely than the Minoans to paint objects from nature on their pottery, favoring instead images of war and religious ritual. However, they often used the octopus and other marine life as artistic motifs, which reflects their reliance on the sea.

While the octopus on this Mycenaen goblet (far right) is an inherently Minoan motif, it is more stylized than its Minoan predecessors and demonstrates the Mycenaean passion for symmetry. With its wide, staring

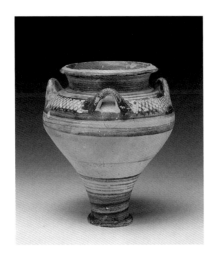

eyes and four (instead of eight) swirling tentacles, the octopus shares the surface of the vase with a typically Mycenaean decoration of horizontal bands that cover the stem and base of the goblet.

One of the Mycenaeans' trading partners during the fourteenth and thirteenth centuries B.C. was the island of Cyprus, which attracted traders because of its rich deposits of copper (*kypros* is the Greek word for "copper") and its strategic location

in the eastern Mediterranean. Hosting foreign travelers and settlers was part of everyday life, and Cypriots learned to be receptive to foreign ideas. Thus it is not surprising that they eagerly embraced the new shapes and decorative motifs of Mycenaean pottery and adapted them for their own use.

Although the ring base and pale clay of this amphora (left) identify it as Cypriot, the broad shoulders, three upright handles, and horizontal bands layered with cross-hatching are all skillful adaptations from Mycenaean prototypes.

Goblet
Mycenaean, circa 1400–1300 B.C.
Terra-cotta; height 6 13/16 inches (17.3 cm)
Purchase, The Arthur and Margaret Glasgow Fund, 60.8

Amphora
Cypro-Mycenaean, circa 1400–1300 B.C.
Terra-cotta; height 6 1/4 inches (15.9 cm)
Gift of the Crawford Foundation, 91.70

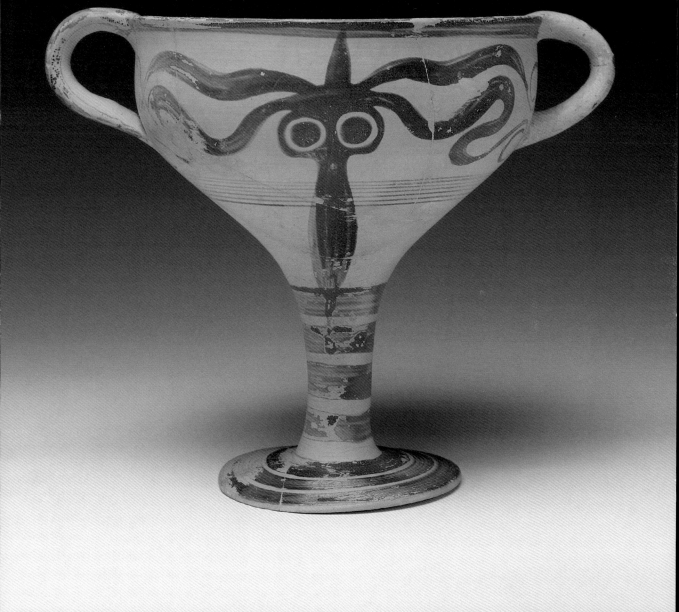

GREEK ART

Emerging around 1100 B.C., the Greeks were relatively late arrivals among the cultures of the Mediterranean. In a span of about five hundred years, they transformed themselves from scattered, small-scale farmers to urban sophisticates living in city-states with various types of government, including (at times) democracy. They defined themselves not by geography, but by their common language, calling non-Greek speakers barbarians because their language sounded like so much "bar-bar" (nonsense). "Greece" was any place Greek-speakers lived; including South Italy, Sicily, North Africa, Asia Minor, and the Black Sea coast.

Culturally the Greeks owed a huge debt to Egypt and the Near East: they adapted religious cults, artistic motifs, and methods of manufacture from earlier civilizations in both these areas, and their alphabet evolved from the one used by the Phoenicians in the Near East. Yet Egyptian and Near Eastern artists worked largely at the direction of rulers and priests, and their artistic traditions were necessarily conservative. In Greece, however, where there were few complex religious institutions and no central government to interfere with a consumer-driven economy, artistic innovation and development came more rapidly.

Greek artists, poets, philosophers, and historians looked to humanity for their inspiration—the beauty of the body, the magic of music and language, the mystery of human relationships and human actions. The center of the Greek experience, compared with that of Egypt and the Near East, was the belief that the individual—not a ruler, not a priest,

not a god—is the proper focus of human endeavor. It is not an accident that most Greek temples were built to human scale, whereas those in Egypt and the Near East were overwhelmingly large. In the Classical Period (sixth through fourth century B.C.), artists sought to express the best qualities of humanity in "ideal" images; in the Hellenistic Period (late fourth through first century B.C.), society's fascination with character types, not all of them admirable, led artists to portray human subjects in less than ideal forms as well.

Greek religion reflected the complexities of human behavior. Although the Greek gods had supernatural powers, they appeared in human form, participated in human activities, and displayed human emotions. Greek mythology, which was full of stories about the gods and their relationship to human beings, inspired creativity in both art and literature. However, there were no "official" versions of these stories as there were in Egypt. Greek mythology was transmitted orally, in the form of songs, recitations of poetry, and plays, and pictorially, on everything from public buildings to articles for personal use. Today we have only some of the written records and works of art to help us understand Greek mythology. In some cases, the art illustrates myths for which we have no written records.

The heritage of the Greeks has been preserved through the admiration of the people who followed them, from Roman times to our own. Nearly everything the Greeks accomplished reflects their human focus, and it is this celebration of humanity that has made their legacy so enduring.

Eulogies in Clay

Created to accompany the deceased into the next life, these early Greek vases are masterpieces of design and decoration.

The earliest Greek pottery, which dated from about 1100 to 750 B.C., was decorated mainly with geometric patterns. In the best examples, Greek vase-painters used these patterns to emphasize a vessel's parts—mouth, belly, foot—and to achieve a sense of harmony and rhythm on the entire piece. This sensitivity to form continued to develop beyond the Geometric Period and is apparent throughout the history of Greek vase-painting.

The most prominent center of production for Greek Geometric pottery was the Kerameikos, located at the edge of ancient Athens, capital of Attica. The unusually fine Attic clay attracted outstanding potters and painters, and the Athenian economy provided the demand for vases, both at home and abroad. Artists used the same clay both to form the vases and to create the luscious black and rust-colored "glazes" and pale "slips" that decorated them. Applied before the vases were fired, the clay "paints" turned different colors according to the amount of iron in the clay and the conditions in the kiln.

The *Pyxis* on the facing page, a container for cosmetics or other precious items, was probably made especially for its owner's tomb. Every paintable space is filled with concentric circles (made with a multiple-headed brush),

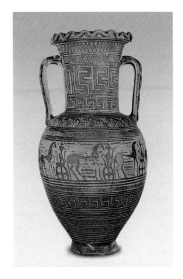

chevrons, and a cross-hatched meander. The painter could not resist decorating even the underside of the pyxis (below), where he used a compass to create a stylized, fourteen-petal rosette. Two pairs of holes were punched on opposite sides of the lid and lip of the bowl, so a string could be passed through, securing the lid.

By the late Geometric Period, around 750 B.C., Attic vase-painters tended to decorate their pottery with more human and animal figures. The form of this *Neck-Handled Amphora* (above) probably indicates that it commemorated the death of a man— belly-handled amphoras were commonly used in the burial of women.

Here, the painted frieze around the belly shows a parade of chariots reminiscent of funeral processions seen on other vases of this period. The modeled "snakes" added to the lip and handles further suggest that this amphora was intended for a grave: observing that snakes could easily enter the earth and reappear, Greeks considered them examples of rebirth and guardians of tombs.

Pyxis
Greek (Attic)
Late Geometric Period, 760–750 B.C.

Terra-cotta; height 5 11/16 inches (14.5 cm)
Purchase, The Adolph D. and Wilkins C. Williams Fund, and a gift of funds from the Jerome Levy Foundation, 89.3a/b

Neck-Handled Amphora
Greek (Attic)
Late Geometric Period, 740–730 B.C.

Terra-cotta; height 26 9/16 inches (67.5 cm)
Purchase, The Arthur and Margaret Glasgow Fund, 60.50

Below: Underside of Pyxis *reveals rosette.*

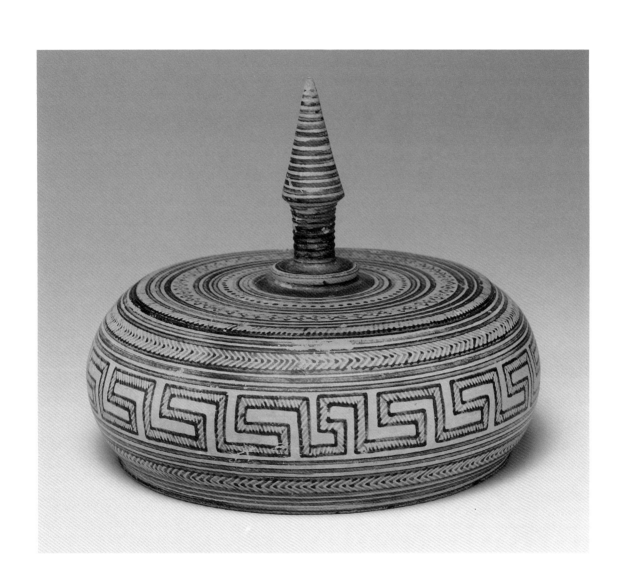

A Taste for the Exotic

Enlivened by exciting motifs from Eastern art, Corinthians created a new style.

A snake slithers between two roosters under the spout of this *Olpe* (wine pitcher). Since snakes in Greek art are often associated with rebirth (see p. 44), this vessel may have been intended for a tomb. The roosters, though familiar to us, were considered exotic by the seventh-century Greeks. The so-called Orientalizing Period (around 730–600 B.C.) was a time of unprecedented trade and contact between Greece and the eastern Mediterranean. Artisans travelling freely between West and East soon exchanged new ideas and techniques, bringing new life to Greek art.

In Corinth, southwest of Athens, the first effects of this new era appeared in its fine painted pottery. As in the East, Corinthian artists liked to paint horizontal rows of animals (often exotic and mythical) and fill the areas around the figures with ornaments, particularly the stylized rosettes shown here.

This vase is an example of Corinthian pottery at its most developed stage, known as "Ripe" Corinthian. The painter, named by scholars the Dodwell Painter, has mingled real animals with fantasy creatures: in the bottom row a Siren or woman-headed bird spreads her wings, and in the middle row a Boread, one of

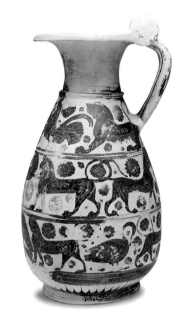

the winged sons of the North Wind, is shown with both arms extended and his legs in a "kneeling run." (This "Running Gorgon" pose is a common Eastern motif.)

On this pitcher, the Greek artist's palette has broadened to include matte purple paint (made from clay and red ochre, applied before firing). Significantly, the practice of adding engraved details to the painted figures, begun by Corinthian artists, developed into the black-figure technique employed so well by Athenian vase-painters

later in the sixth century. The function of this vase as a pitcher is evident from its broad mouth and single vertical handle. The disks on either side of the handle, where it joins the lip of the vase, are thought to reflect a form invented by metalworkers.

The shapes of Greek vases varied little over the centuries. Some of the names that scholars use today for these shapes were used in ancient times, others are only guessed at. The *amphora*, a two-handled jar that often came with a lid, stored wine; the *hydria*, a water pitcher, had three handles, two horizontal ones for lifting the full pitcher and a vertical one for pouring. The *krater* was a large bowl for mixing wine and water, and cups were filled with wine from ladles or pitchers dipped into the krater. Containers for personal items included small-mouthed vessels for oil (*lekythos, alabastron, aryballos*) and the box (*pyxis*) for cosmetics and jewelry.

Greek (Corinthian), 590–580 B.C.
Terra-cotta; height 17 5/16 inches (44 cm)
Purchase, The Arthur and Margaret Glasgow Fund, 80.16.

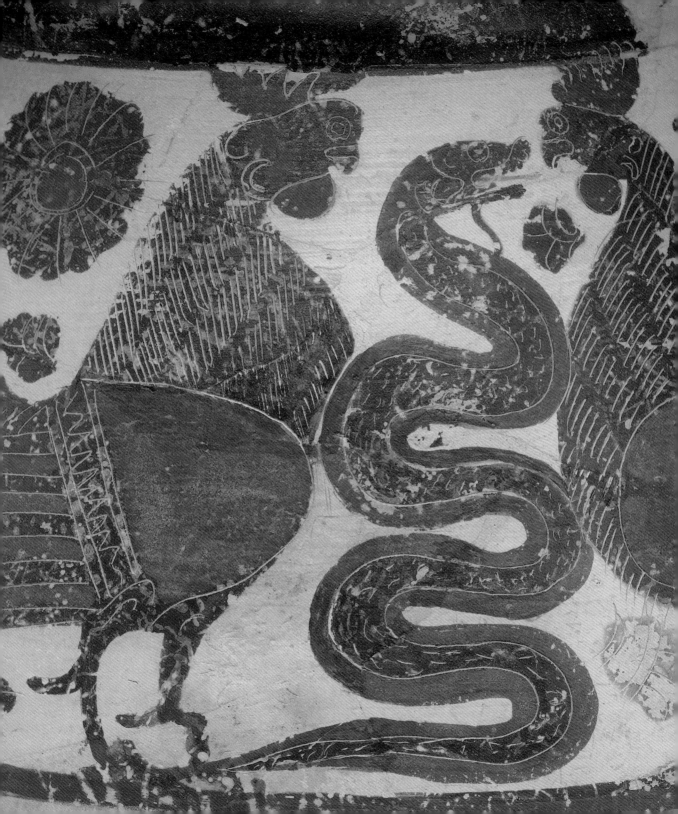

Spartans with an Eye for Beauty

The arts flourished in sixth-century Laconia, proving that Attica was not the only home of Greek artists.

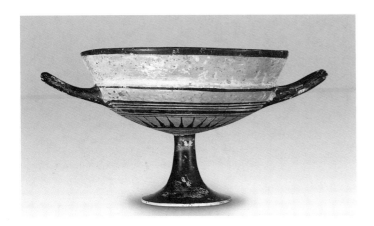

Anyone sipping wine from this cup would have been greeted by the festive scene of a man playing a double flute while a youth and a bearded man dance exuberantly around him. The fish swimming below would have been submerged in a sea of wine until the cup was empty. This lively scene contradicts the "bad press" Athens gave Sparta, Laconia's prominent city-state, when the two were at war a century later. Sparta was unquestionably a strong military and economic force, but during the seventh and sixth centuries it was also a center for the arts.

Laconian pottery is characterized by the light buff color of its clay, in contrast with the yellow clay of

Corinth and the deep orange clay of Athens. As Corinthian vase-painting declined in the sixth century, Laconian vase-painters created their own style using the new black-figure technique, primarily for drinking cups. Laconian artists solved the problem of filling the round, concave surface or "tondo" inside the bowl by painting a solid line for the figures to stand on. In the exergue, the area below the line, they usually depicted some minor ornament or figure.

In typical Laconian fashion, the painter left the outer surface of this cup quite plain, with several rows of horizontal lines and a band of rays as the only decoration. The lower part of the bowl is darker than the

upper, the result of a reddish wash that extends from the base of the handles to where the bowl joins the stem. The edge of the lip, the handles, and the base are all painted black.

Corinthian vases of this period often showed padded dancers participating in a *komos*, a type of religious rite involving dancing and drinking. While the "komasts" here appear to be nude, their plump stomachs, rumps, and thighs are reminiscent of the Corinthian type. At Athens they may have been forerunners to the dramatic chorus, while at Sparta they may have been dancing to honor Artemis Orthia, a local variation of the goddess.

The painter of this cup, like many vase-painters, did not sign his name, but scholars are able to assign it to an artist known as the Rider Painter, after his cup in the British Museum that depicts a rider on horseback.

Greek (Laconian), 545–535 B.C.
Terra-cotta; height 3 13/16 inches (9.7 cm)
Purchase, The Adolph D. and Wilkins C. Williams Fund, 82.1

Right: Interior of cup shows figures standing on a solid line.

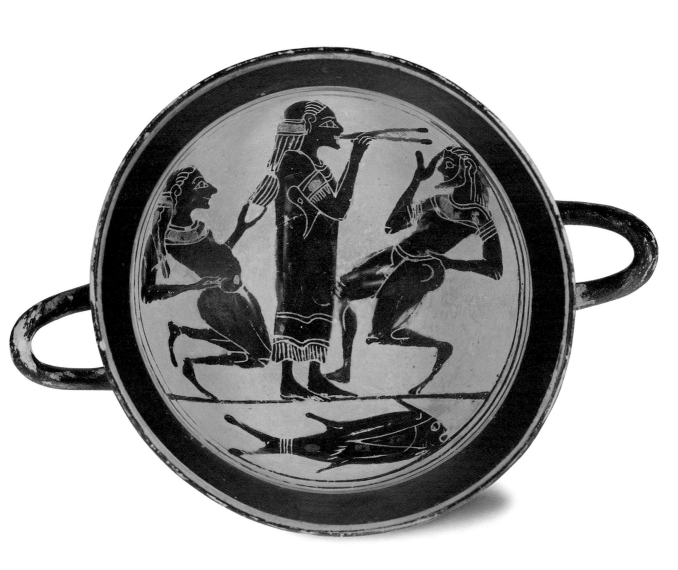

Checkmate!

Greek warriors find a moment to relax during the Trojan War.

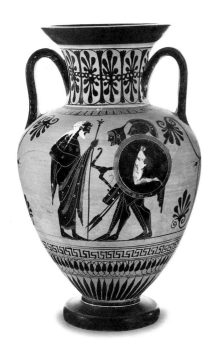

The two Greek warriors on this *Neck-Amphora* have put aside their helmets and shields to play a board game, presumably taking advantage of a lull between battles. They are still holding their spears, however, ready to return to action at any moment. Squatting before the game board, the warrior on the left seems to have made a move with one of the black or white game pieces, and his opponent on the right gestures excitedly. The goddess Athena, holding her spear and wearing an elaborate helmet and snake-bordered *aegis* (breastplate), stands behind the game board in a stiff pose, perhaps to indicate that the figure is a statue. The white paint covering her skin is a standard way of depicting females in the black-figure technique. (Originated in Corinth and perfected in Athens, capital of Attica, the black-figure technique placed figures done in black paint against a natural clay background, with the detail achieved through incision.) Here the composition skillfully balances mass and detail and directs the viewer to the action in the center. The artist has been associated with the so-called Leagros Group, which produced the last great black-figured vases.

The first of many vase-painters to render this scene may have been the great Athenian master Exekias, who used it to decorate an amphora in about 540 B.C. and added an inscription identifying the warriors as Ajax and Achilles. These two Greek heroes, friends and comrades during the Trojan War, were famous for their bravery and sense of honor: Ajax killed himself after rescuing Achilles' body on the battlefield but failing to win Achilles' armor at the funeral games.

On the other side of the vase (left) an old man holding a staff greets an archer and a hoplite (foot soldier). The two warriors are outfitted according to convention: the archer with a soft hat, bow, and quiver; the hoplite with a crested helmet, short cloak, greaves to protect his shins, two spears, and a shield. The shield is emblazoned with a running human leg in added white, which may refer to his swiftness in action.

Greek (Attic), circa 510 B.C.
Terra-cotta; height 16 ½ inches (41.8 cm)
Purchase, The Adolph D. and Wilkins C. Williams Fund, 60.10

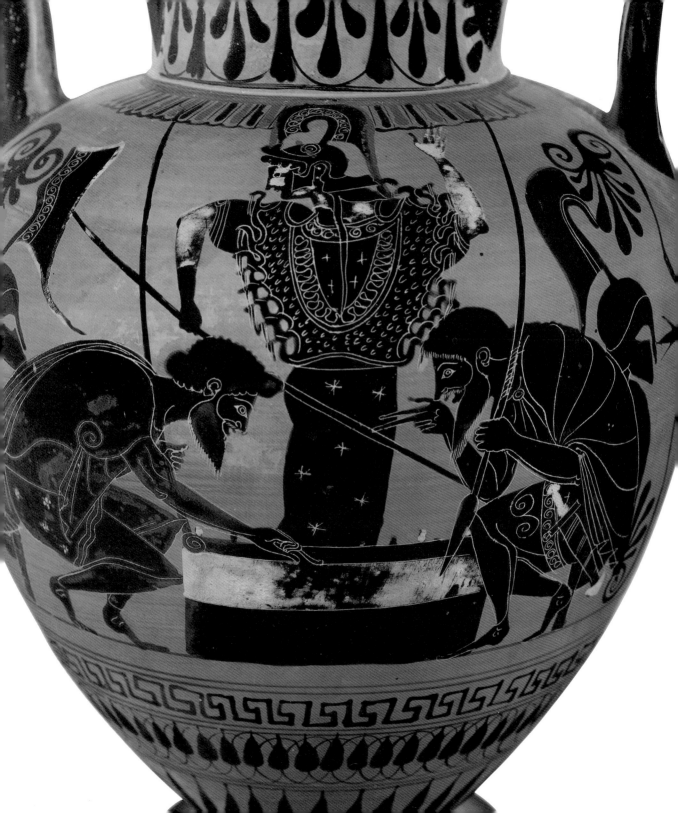

Libations for the Gods, from the Gods

On this masterpiece of painting, a red-figured vase from Athens, Apollo and his sister Artemis pour wine at an altar.

In about 530 B.C., Athenian vase-painters invented a new way to draw figures on terra-cotta vases. The new technique allowed them to render their subjects with more realism and greater artistry than before. Instead of putting black figures on a red background and incising the details, artists made the background black and left the figures red so that they could use paint for the details. The results were astounding: now they could shade or highlight objects, overlap and intertwine figures, and vary the thickness of the paint. Above all, lines flowed far more quickly and smoothly from a brush than from an incising tool. Some of the early painters worked in both techniques, using red-figure on one side and black-figure on the other.

On the front of this *Neck-Amphora*, a vessel for storing wine, the god Apollo pours wine onto a low altar. (The Greeks usually began a drinking party by making an offering of wine to the gods, and apparently the gods themselves felt obliged to make offerings as well.) The most handsome of all the gods, Apollo was the patron of music and poetry (the main elements of education). The *cithara*, a version of the lyre, was his preferred instrument. Here, Apollo is elegantly dressed in a long, pleated

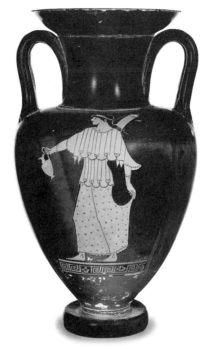

chiton (gown), which is fastened on the right arm with three buttons, and a *himation* (cloak) with a red band at the bottom edge. He wears a crown of laurel, a plant sacred to him, and has bound up his long hair at the back. His cithara—the "concert grand" of lyres with a wooden box-type sounding board, knobs for tuning, and a pick attached by a red ribbon— is further bedecked with a long,

decorative sash and a cascade of ribbons that parallels the flow of wine onto the altar. With his fingers poised on the strings, Apollo seems about to begin a concert. He will probably sing as he plays.

Apollo's twin sister, Artemis, virgin goddess of the hunt, appears on the other side of the vase. Dressed in a patterned chiton and short himation (appropriate for hunting), she wears simple jewelry: bracelets, a necklace, and a crown with upright leaves. Her long hair is bound neatly with a red ribbon, and she carries her quiver on her back as she approaches the altar to refill Apollo's cup from a pitcher. Scholars call the artist the Berlin Painter after his masterpiece in the Staatliche Museen, Berlin. He was fond of decorating his vases with a single figure on each side, sometimes above a short patterned band, as here. His elegant drawing and his distinctive patterns and palmettes (below the handles on this amphora) are hallmarks of his style.

Greek (Attic), 470 B.C.
Terra-cotta; height 11 ⅝ inches (29.5 cm)
Purchase, The Arthur and Margaret Glasgow Fund, 82.204

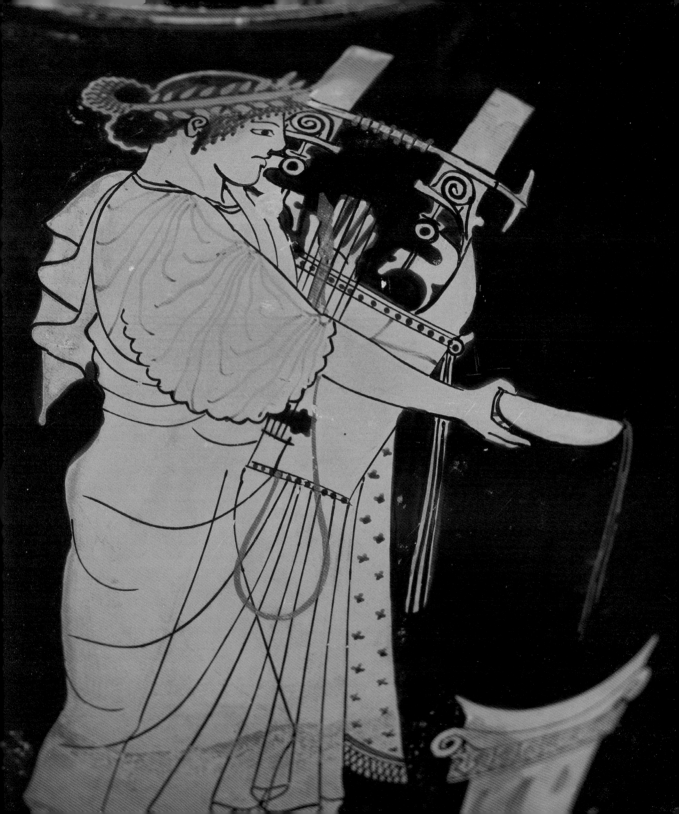

Loss and Love in Magna Graecia

Reflecting the unique style of western Greek vase-painters, this monumental vessel offered consolation to a grieving family.

By the fifth century B.C., the Greek colonies in South Italy and Sicily had become wealthy from trade and agriculture and relished their reputation as part of Magna Graecia (greater Greece). When Athenian vase production declined at the end of the fifth century, these western Greeks developed their own pottery tradition using native clay to achieve new aesthetic and spiritual goals. This funerary vase—more than three feet tall—is an example of their love of show, which translated into an exuberant use of color and design to celebrate life, even as the vase commemorated the dead.

Mourners commonly left small oil-filled *lekythoi* at tombs, but this huge one, made intentionally with a hole in its bottom, served a symbolic purpose. It depicts the myth of the young Kephalos, who was whisked away by Eos, goddess of the dawn, while he was on a hunting expedition with his friends and *paidogogos* (tutor). The subject was appropriate for a tomb because it suggested that the young die because the gods desire them. The artist composed the scene in two registers, with gods above and mortals below. Framed by a red "halo" above their heads, the loving couple rush away in a chariot pulled by white horses. Surrounding them are gods of love and celebration: Hermes, the messenger, with his magic staff; Aphrodite, goddess of beauty, love, and marriage, with her mirror and jinx wheel (one turn of which can bring back a wayward lover); and Apollo, patron of music (not visible in the photograph). Two Erotes, winged children associated with Aphrodite, flutter about with garlands and another jinx wheel. The gods' joy counterbalances the woe of Kephalos's companions.

The wild creatures—hares, birds, a fawn, even a boy satyr—and luscious floral ornament on the shoulder, neck, and back of the vase lend gaiety and excitement. The face of a gorgon on the back fiercely guards the tomb. The artist of this vase is known as the Underworld Painter, after the subject of his masterpiece in the Museum Antiker Kleinkunst in Munich.

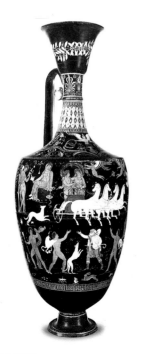
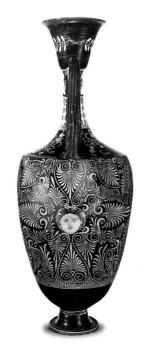

Greek (South Italian, Apulian), 350–340 B.C.
Terra-cotta; height 37 7/16 inches (95 cm)
Purchase, The Adolph D. and Wilkins C. Williams Fund, 81.55

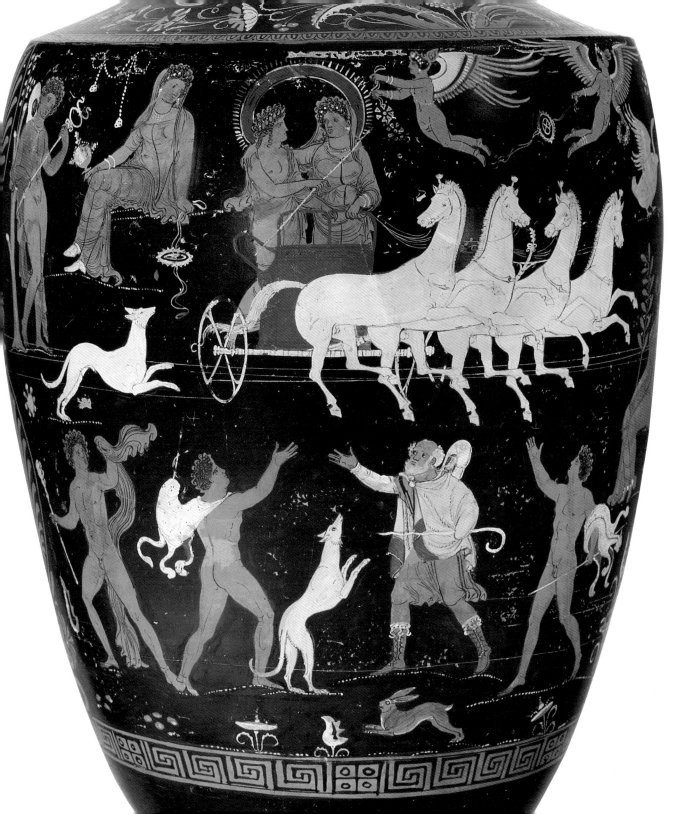

Sublime in Music, Powerful in Form

The spirit of the god Apollo lives on in this copy of a Greek masterpiece.

The torso of the god Apollo on the facing page is what remains of a Roman replica of a famous Greek masterpiece. Carved in the fourth century B.C., possibly by the great sculptor Praxiteles, the original stood in a gymnasium called the Lycaeum. The statue must have still been there six hundred years later since the Greek orator Lucian describes it in

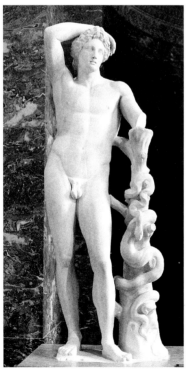

Large-scale replica of Apollo Lycaeus *in Musée du Louvre, Paris.*

that location. In ancient Athens, the gymnasium provided training for young men in both mind and body. A typical gymnasium included athletic fields, dressing rooms and baths, and shaded courtyards for instruction and discussion. The renowned Greek philosopher Aristotle taught at the Lycaeum, and it was there that Apollo—patron of education, music, poetry, and culture—was honored with the life-sized original sculpture. The type came to be known as the "Apollo Lycaeus."

The *Apollo Lycaeus* stood with his right forearm resting on top of his head, his weight on the right leg. His left arm is lowered to hold his bow. Lucian tells us that nearby once stood Apollo's bronze tripod, which he had won from Herakles by brute force. Eventually, the tripod became a standard prize for winning such events as musical or theatrical contests. The original sculpture may have been famous for its harmonious portrayal of Apollo's power (represented by the bow), his victory (the tripod), and his ability to inspire mortals through music and song. In ancient times, viewers would have recognized the statue as portraying the god himself overcome by sublime music and song.

The Romans deeply admired Greek statuary and often commissioned copies of famous Greek originals. The quality of the Roman reproductions varied greatly, depending on the skill of the sculptor-copyists (often Greek slaves) and whether they were working from the original or from a copy of a copy. Often, the Roman versions are all we know about the originals. Art historians have identified about a hundred ancient copies of the *Apollo Lycaeus* in various degrees of preservation. The torso illustrated here is especially finely carved, and is unusual because of its relatively small scale. The finest large-scale and nearly complete replica (left) is in the collection of the Musée du Louvre, Paris. The snake entwined around the tree-trunk represents Python, a serpent that Apollo slew when he established his sanctuary at Delphi.

Graeco-Roman, circa A.D. 100–200
Roman copy of a Greek original from 400–300 B.C.

Marble; preserved height 11 inches (27.9 cm)
Purchase, The Arthur and Margaret Glasgow Fund, 96.6

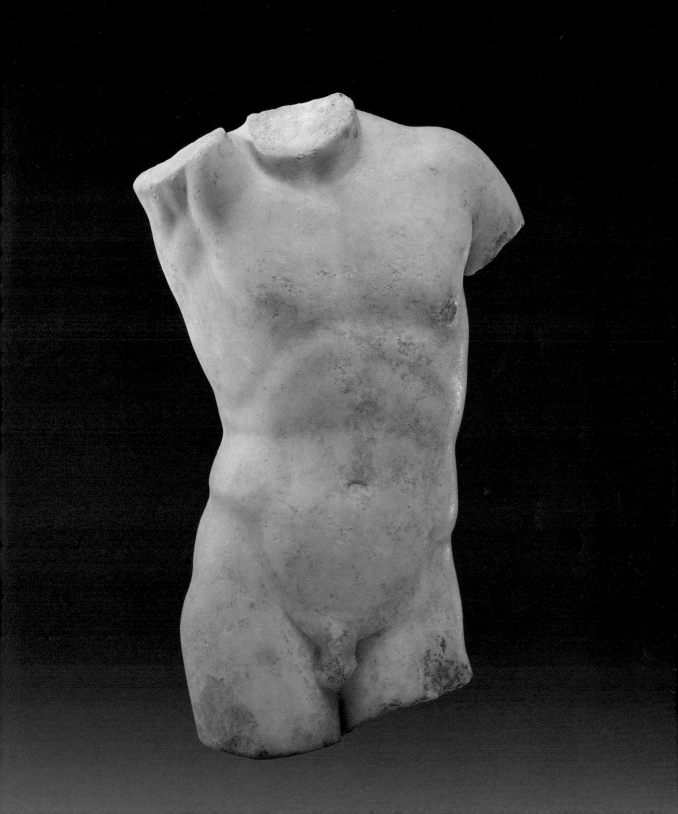

Images of Life to Honor the Dead

A woman in her prime reminds us of life's brevity, while a flowering acanthus brings hope of renewal.

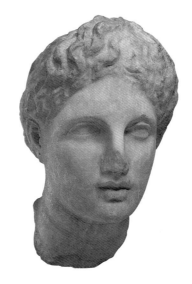

The carved marble slab shown on the facing page is the upper part of a stele, or tombstone, that originally stood about six feet tall. In contrast with the awkwardly inscribed name of the deceased (Philoneios) and his district (Prospalta, near Athens), the sensitively carved acanthus palmette atop the stele is a tour-de-force of the sculptor's art. This decorative addition seems to have a message of consolation: despite the fates of individuals, life and nature continue. (The floral embellishments recall the Greek South Italian *Red-Figured Lekythos*, p. 54.)

Carved in relief on the shaft of the stele is a large oil vessel—a lekythos or loutrophoros, a type of vessel commonly left at the grave—but on this fragment only the neck and mouth survive. (Stone vessels of this shape, carved with images of the deceased, were also popular as monuments during the fourth century B.C.) Traces of a painted egg-and-dart pattern remain on the molding above the inscription and suggest that the palmette was once painted as well.

A fourth-century Greek marble head (above), also in the collection of the Virginia Museum of Fine Arts,

may represent another type of funerary monument or tombstone in which figures of the deceased and family members were carved within in a shallow, roofed façade, a sort of "house of the dead." Sometimes the sculptor worked in such high relief that the heads of the figures stood clear of the background. In this case, the asymmetry of the face suggests strongly that the sculptor intended the figure to be seen mainly from its right side. The angle of her head and eyes also suggest this. The deep-set eyes, soft, plump face, and full, slightly parted lips are common

features of fourth-century sculpture. She was probably painted and wore earrings (note the holes in her earlobes).

At Athens the main place for burial was in the Kerameikos cemetery, which was outside the city walls near the potters' quarter. The monuments in that cemetery shown in the photo below are casts of fifth and fourth century B.C. originals that were found in the Kerameikos and are now in museums in Athens.

"Flame-palmette" Stele
Greek, circa 350 B.C.
Marble; height 26 5/16 inches (66.8 cm)
Purchase, The Arthur and Margaret Glasgow Fund, 79.148

Female Head
Greek (Attic), circa 325 B.C.
Marble; height 12 inches (30.5 cm)
Purchase, The Adolph D. and Wilkins C. Williams Fund, 57.19

Kerameikos cemetery is outside Athens.

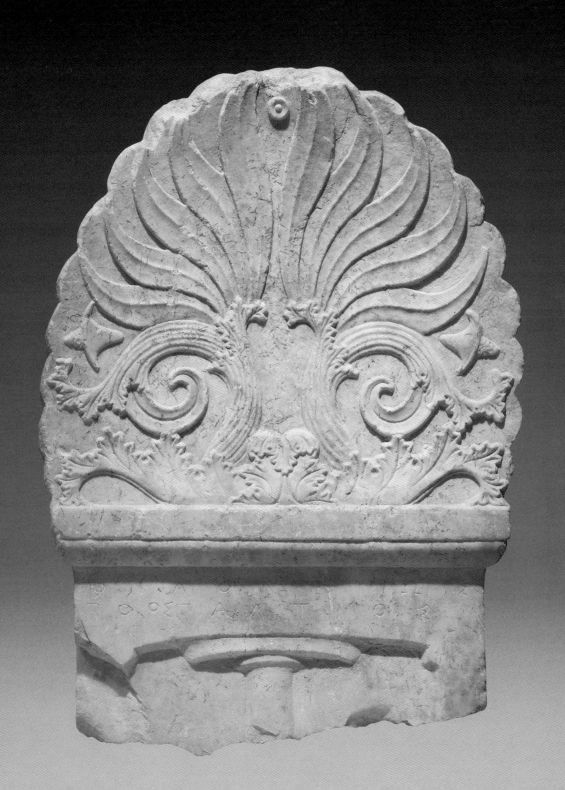

The Hellenistic Touch

A familiar feminine gesture seems both delicate and sensuous.

The Greeks placed a high value on the safety and reputation of their women. Proper Greek women spent most of their time at home, and even then they were usually in the women's quarters. When they did go out, they were always covered with clothing from head to toe.

The sculptor of this statue of a young woman has caught her in the act of adjusting her cloak (himation) in a feminine gesture that simultaneously reveals and conceals. Holding the cloak around her with her left hand, she lifts her right arm to pull it over her shoulder. The resulting heavy folds serve as a picture frame, drawing our eyes to her torso and her sheer, clinging chiton (dress). In this way, the sculptor calls our attention to her feminine charms while maintaining a sense of decorum—a common device of Hellenistic sculptors. Also typically Hellenistic are the fashion in which her dress has been bound by ribbons beneath her breasts and over her shoulders

and the juxtaposition of elaborate folds against smooth areas of fabric or skin.

Who is she? Because the back of the statue has been left relatively unworked, we might guess that the figure was made to stand in an architectural setting where the back would not be seen. Her modest pose and youthful figure suggest that she may be one of the Graces or a nymph rather than Aphrodite, the goddess of beauty, love, and desire.

Greek, Hellenistic Period
circa 300–200 B.C.

Marble; height 26 inches (66.1 cm)
Purchase, The Adolph D. and Wilkins C. Williams Fund, 64.50

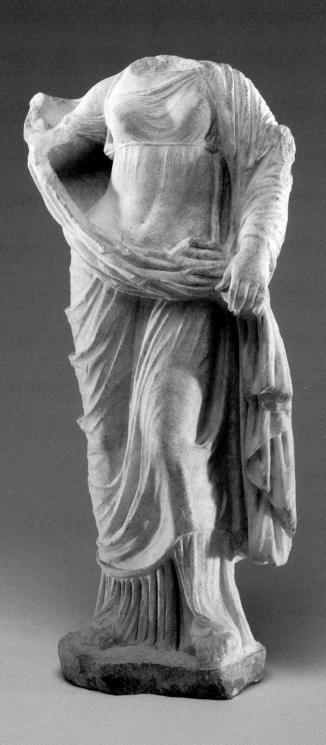

Forever Young

The poignant image of a small boy captures the innocence of childhood.

A young boy, about three years old, stands with his head tilted downward. Although he is just a child, he wears the clothing of an adult—a thick himation (cloak) draped over his left shoulder and arm, and wrapped around his body from the chest down. His hair has been shaved, except at the back, where it is arranged in a braid similar to the one worn by Horus, son of the Egyptian mother-goddess Isis, whose cult was popular at this time in the Greek and Roman world. This "Isis braid" or "lock of Horus" was worn as protection against harm until a boy reached young manhood.

Images of children were relatively rare in Greek and Roman art, although they appeared on tombstones and other funerary markers as early as the sixth century B.C. Parents dedicated statues of their children at sanctuaries of protective deities such as Isis and Asclepios, the healer. Hellenistic sculptors often showed curly-haired tots playfully squeezing

geese or taking naps. The sculptor of this statue, most likely from a cemetery or sanctuary, has laid aside the playfulness, giving the boy a somber look: his clothes are those of a philosopher or scholar, certainly a man of substance, a station in life that this wistful boy will probably not attain.

Sculptors rarely showed interest in the special proportions of children's bodies, often portraying them essentially as small adults. However, this statue was carved by a master who has paid careful attention to the size of the little boy's head in relation to his body. (The head is separate from the body, though we do not know if the original statue was made from two pieces of marble or a single stone that was damaged and repaired in antiquity.) The hint of a child's prominent tummy can be seen beneath the drapery, and the artist has created in marble the illusion of soft, rounded cheeks and lips that seem fresh and real, even after two thousand years.

**Greek, Hellenistic Period
circa 200 B.C.–A.D. 100**
Pentelic marble; preserved height 34 ½ inches (87.6 cm)
Purchase, The Adolph D. and Wilkins C. Williams Fund, 89.24.a/b

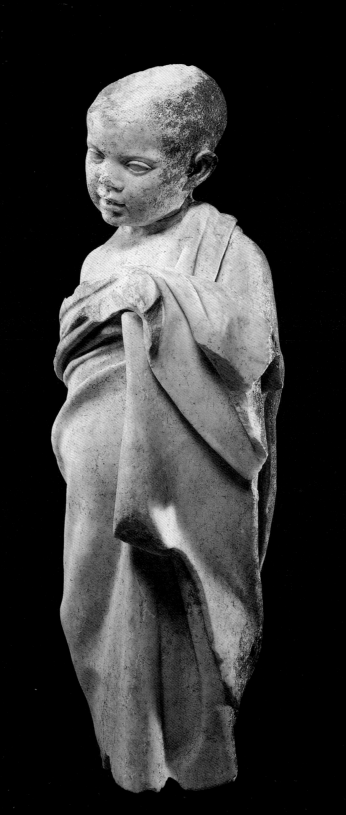

Glitter from the Grave

The Hellenistic Greeks tried to take it with them, preserving their wealth for us to enjoy.

The allure of gold was as powerful in the ancient world as it is today. It was scarce in the lands around the Mediterranean until Alexander the Great (who ruled from 334 to 323 B.C.) raided the treasuries of eastern kingdoms and brought massive amounts of gold and gold jewelry back to Greece. With their new wealth, the Greeks' appetite for gold jewelry increased, and they began to fashion their own. Most Greek jewelry known today has been found in tombs or in hoards hidden by owners or even jewelers in periods of unrest. Some of the richest finds of Hellenistic jewelry have been in South Italy and northeastern Greece (ancient Macedonia).

In its natural state, ancient gold was an alloy with varying amounts of silver, copper, and other minerals. Because these natural alloys melt only at very high temperatures, ancient jewelers could create relatively intricate work with few tools. ("Karat" refers to a unit of gold in modern, man-made alloys, which melt at lower temperatures and are difficult to work without using special tools.)

This wreath and ring are from a group of seven pieces of jewelry said to have been found in a tomb near

Amphipolis, in Macedonia. The dates of manufacture of the seven items span about a hundred years, suggesting that they had been collected as family heirlooms.

In ancient Greece, leaves of fresh ivy, olive, bay, and other plants were made into crowns and wreaths and worn for an array of events and ceremonies. Although gold wreaths may seem too fragile for actual use, literary evidence indicates that they were worn for special occasions. The forty-eight leaves on this wreath, each made with a central "vein," are arranged in groups of three and fastened to a hollow gold tube, to

imitate an olive branch. At each end of the main stem there is a small loop to which ribbons would have been attached, to secure the wreath to the wearer's head.

The ring (left) was made from a flat strip of gold that was formed into four coils. Details, such as the herringbone pattern on the snake's head and the oblique lines on the tail, were achieved by chasing—a technique in which the goldsmith gently taps on the end of a tool to raise or punch decorative detail into the metal. If the ring was worn in everyday life before being placed in the tomb, it would have been especially ostentatious because the wearer would not have been able to bend his or her finger. The motif of the serpent was appropriate for the tomb, since the serpent symbolized rebirth (see pp. 44 and 46).

Olive Wreath
Greek, Hellenistic Period, circa 300 B.C.
Gold; stem diameter 9 ⅜ inches (23.8 cm), maximum leaf length 2 ⅜ inches (6 cm)
Purchase, The Arthur and Margaret Glasgow Fund, 65.43.1

Ring in the Form of a Serpent
Greek, Hellenistic Period, circa 300 B.C.
Gold; length 1 ¾ inches (4.5 cm)
Purchase, The Arthur and Margaret Glasgow Fund, 65.43.5

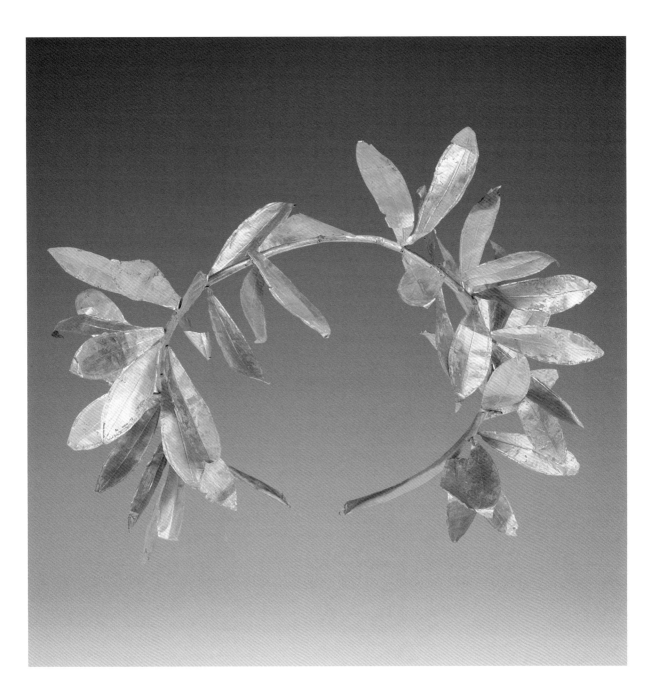

ETRUSCAN ART

One of the most mysterious civilizations of the ancient world is that of the Etruscans, who lived in central Italy from the eighth to the first century B.C. Probably descended from an earlier, indigenous people known as the Villanovans, the Etruscans left few written records, mainly religious in nature. As a result, our main sources of information about the Etruscans are their art and architecture and the writings of the Roman historian Livy in the first century B.C.

As late as 600 B.C. Etruscan temples were still being built with squat, heavy proportions from wood and mud-brick because the Etruscans lacked access to the limestone and marble available to the Greeks. Because of the impermanent nature of Etruscan building materials, the most commonly preserved architectural remains are foundations made of tufa, a volcanic pumice, and terra-cotta revetments (facings) used to protect exposed wooden beams and roofs from inclement weather.

The subterranean tombs of the Etruscans were filled with art—colorful wall paintings, sets of dishes for the funeral banquet, gold jewelry, sculpture, religious and utilitarian bronze objects, and imported luxuries such as vases from Athens. In fact, the Etruscans were perhaps the largest market for Attic vases in the ancient world. Until the production of fine pottery at Athens declined in the late fifth century B.C., Attic vases outnumbered local vases in Etruscan tombs four to one.

Etruscan figures are easy to recognize by their distinctive proportions and features: stocky anatomy, large hands and feet, full smiling mouths, and almond-shaped eyes—and they are almost always wearing the famous Etruscan footwear, known in Latin as *calcei repandi*, or little pointed shoes. In their art, the Etruscans used the human form to capture and preserve the expression of emotion: the joy of a dancer in mid-pirouette, the exertion of an athlete in full stride, the love of a couple in fond embrace.

Militarily strong, the Etruscans dominated Italy for centuries, and Etruscan kings ruled in Rome from 700 to 509 B.C. The prosperity and security of this period is reflected in their art: tomb paintings with scenes of men and women feasting and drinking, boys fishing and diving into the tranquil sea, and musicians and entertainers performing.

When the Etruscans were driven from Rome in 509 B.C., their sudden change of fortune deeply affected their outlook: with their gradual decline and eventual absorption into Roman culture, images of death and despair filled their tombs—winged, monstrous death demons appear to escort the dead to a misty, bleak underworld, a dismal version of the Greek Hades. After generations of battles with Rome and neighboring tribes, the Etruscans were eventually incorporated into Rome's expanding territories by 100 B.C.

A Model Home

Was this urn meant to represent a final resting place, or a way-station on the journey to the next life?

This urn, shaped like a miniature hut complete with roof and door, was created by a potter of the Villanovan culture, which flourished on the Italian peninsula during the tenth through the eighth centuries B.C. Generally considered ancestors of the Etruscans, the Villanovans were named by scholars after Villanova, a site discovered near Bologna in 1853. Apart from objects found in their burial pits, little is known of them. Urns for cremated remains of the dead, bronze weapons and tools, jewelry, and pottery tell us that farming, raising horses and cattle, and metalworking were major Villanovan industries. These pieces were often beautifully decorated with painted, stamped, or incised geometric patterns, or small, dangling rings.

Handmade from a dark clay known as impasto, this hut urn is decorated in typical Villanovan style with geometric patterns incised and painted (with a white clay slip) on a matte surface. The bold squares-within-squares, set off by both the dog-tooth borders and the round curves of the base and top, give the urn a feeling of weight and permanence. The ridges on the roof repre-sent the wooden rafters used in actual buildings, and the openings at either end must have provided ventilation. The stylized birds seem-ingly perched on the ends of the beams echo the habits of birds in nature and may reflect actual architectural elements that were precursors to the Etruscans' love of roof decoration. Villanovan hut urns are particularly interesting because they suggest how Villanovan buildings were constructed: oval in plan, with wooden beams, thatched roofs, and adobe-style walls.

~~~~~~~~~~

**Villanovan, circa 800–700 B.C.**
Terra-cotta; height 12 7/8 inches (32.7 cm)
Purchase, The Adolph D. and Wilkins C. Williams Fund, 79.15 a/b

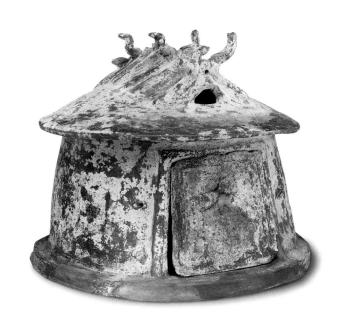

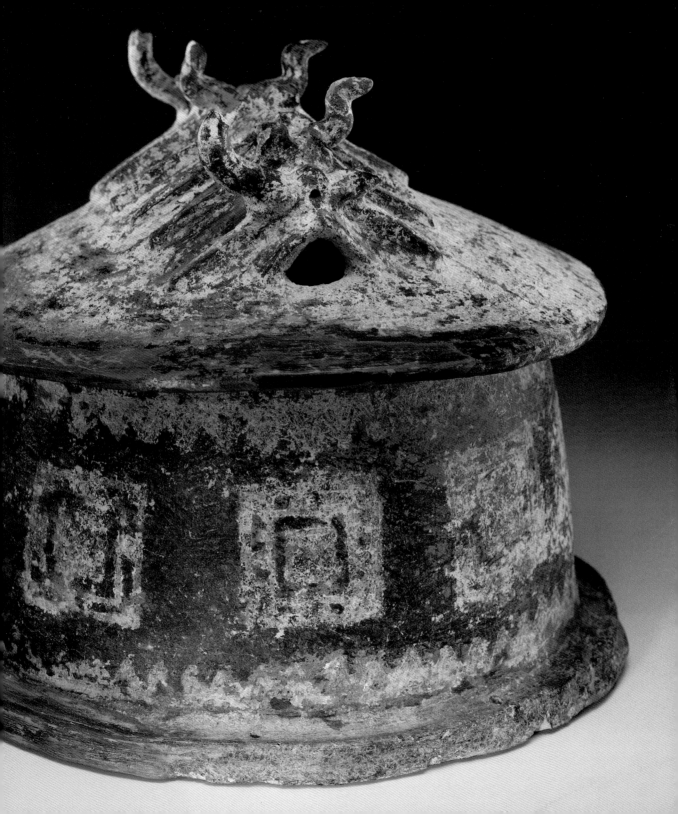

# An Elegant Etruscan Embellishment

Like a comely gargoyle, this rooftop maiden once smiled through sun and rain.

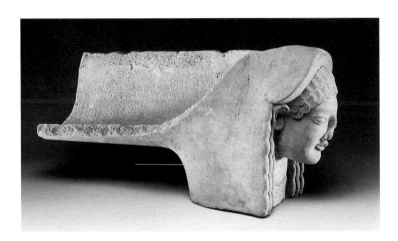

The glory of Etruscan buildings was their elaborate roof decoration. Lacking fine marble, the Etruscans fashioned their buildings out of wood and tufa and protected them from rain and snow with tiles, gutters, and plaques made of fired clay. Additionally, they adorned their roofs with masses of painted terra-cotta sculpture, an effect that surely would have seemed top-heavy to a Greek architect.

The front of this roof revetment, or facing, is shaped much like an ordinary roof antefix, a decorative tile that stands upright to seal the open end of a roof tile. Antefixes were often decorated with an animal or human head or a palmette. This one bears the lovely face of a young woman wearing earrings, necklace, and stephane (headdress), her head tilted demurely downward. The back of an antefix was usually formed like an inverted gutter so that it would fit over an upturned roof tile. The back of this revetment, however, forms an open gutter, to channel rainwater to a downspout below the woman's head.

The young woman's almond-shaped eyes, wide, full smile, and braided hair are common in Orientalizing Greek sculpture (sculpture with features borrowed from Near Eastern art). However, the Etruscan sculptor intentionally exaggerated these features in high relief and angled her head so that she could be easily viewed from ground level. Painted detail was added for further emphasis, and much of it is still intact on her hair, disk earrings, pendant necklace, and elaborate dress pattern. The stephane crowning her head may have been painted as well.

Who was this young woman? Perhaps an attendant of a cult that was housed in the building to which the spout was attached; perhaps a nymph, especially if the building was a spring-house. Evidence from other Etruscan buildings suggests that a variety of ornamentation—human, animal, vegetal, or fantastic—may have been used on the same building.

**Etruscan, late 500s B.C.**
Terra-cotta; height 10 15/16 inches (27.8 cm)
Purchase, The Adolph D. and Wilkins C. Williams Fund, 80.29

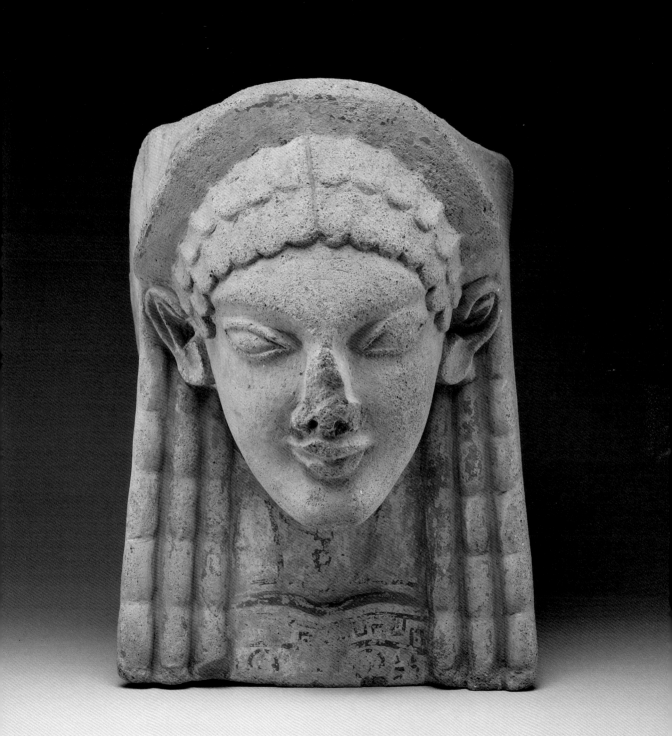

# Greek Theme, Etruscan Variations

Masters of bronze, the Etruscans created their own style.

With shoulders back and fists held tightly at his sides, this young man strides forward with confidence. His long wavy hair falls to his shoulders from a smooth cap (or helmet) with raised edges at his brow and ears.

The pose of this Etruscan figurine resembles the contemporary or slightly earlier Greek *kouros* ("youth") or standing male nude, which in turn was influenced in its early stages by Egyptian sculpture. (The almond-shaped eyes and smiling mouth also appear on Greek statues from this period, and were probably borrowed from the Near East; see the Etruscan *Roof Revetment*, p. 70.) The *kouros* (and *kore* or "maiden," who was usually clothed) dominated Greek art during the Archaic period (600–480 B.C.). Life-size and larger *kouroi* and *korai* were placed in Greek sanctuaries, and smaller versions often adorned luxury objects. These figures may have represented images of deities or devotees.

The Etruscans were clearly influenced by Greek art, but developed their own style. Since they had no marble to carve, they made their sculptures of bronze and terra-cotta. Here, details such as the exaggerated shoulder-to-waist proportions, the thick neck, and the lack of anatomical detail are typically Etruscan.

On a small sculpture such as this, the tang, or prong, beneath the left foot served to stabilize the piece when it was inserted into a base or support. Several possible uses come to mind: the figure may have been made to decorate a stand for oil lamps or a piece of furniture.

〜〜〜〜〜〜〜〜〜〜

**Etruscan, circa 600–500 B.C.**
Bronze; height 4 $7/16$ inches (11.2 cm)
Purchase, The Arthur and Margaret Glasgow Fund, 81.22

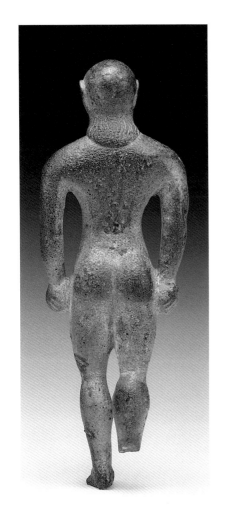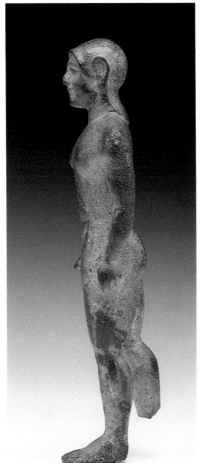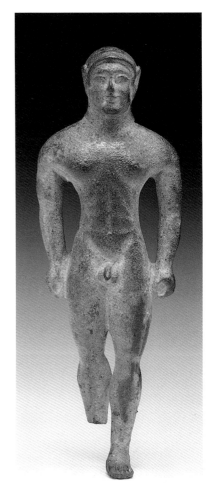

# A Taste for Fine Pottery

The Etruscans' admiration of Greek vases inspired them to fashion their own.

The shape of this Etruscan calyx-krater (a punch bowl resembling a calyx, the set of leaves supporting a flower) —and the red-figure technique with which it is painted—originated in Greece. The multilevel composition and liberal use of added white and yellow reflect the influence of Greek vase-painting from Magna Graecia in the first half of the fourth century B.C. However, the proportions of the figures, the qualities of the clay, and details such as the vulture on the lower right of the main side mark this as an Etruscan work. To date, we know of about a dozen vases by this painter, called the Nazzano Painter after the site in Italy where one of his pieces was found.

The main scene of the vase portrays a battle of Greeks against Amazons, a subject that had been popular in Greece for generations. A race of warrior women said to live beyond the limits of the known world, Amazons were formidable opponents, and Greek victories over them were hard-won (the presence of the vulture signifies the possibility of death). The focus of the scene is the Amazon astride a galloping white stallion. Dressed in

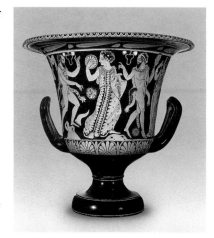

full regalia, including a shield decorated with the face of a gorgon (another wild female creature), she aims her spear at a Greek brandishing a trident. The warrior collapsing on the left completes the triangular composition and echoes the angle of the spear and trident with his outstretched leg.

The battle on the upper level pits two Amazons against three males carrying panther skins, one of whom is so uncouth as to grab a stone for a weapon. The properly armed warrior standing to the left of the tree fills out the composition, but seems to

have no role in the fight. Dietrich von Bothmer, Distinguished Research Curator at The Metropolitan Museum of Art, New York, has suggested several clues to indicate that this scene depicts a mock battle in celebration of Dionysos, Lord of the Underworld and the god of wine, ecstasy, and the Mysteries: the panther skins are attributes of Dionysos, and the fillets and bunch of grapes suspended above the scene are appropriate to Dionysiac revelries. The references to Dionysos continue on the other side of the vase: two satyrs (with their horse tails and goat ears) and two maenads (from the Greek word for "madwoman," so-called because of their joyful, wine-induced ecstasy) dance amid wine vessels and bunches of grapes. The theme of Dionysos was appropriate whether this krater was made for a party or a tomb.

**Etruscan, circa 370 B.C.**
Terra-cotta; height 18 3/16 inches (46.2 cm)
Purchase, The Adolph D. and Wilkins C. Williams Fund, 82.137

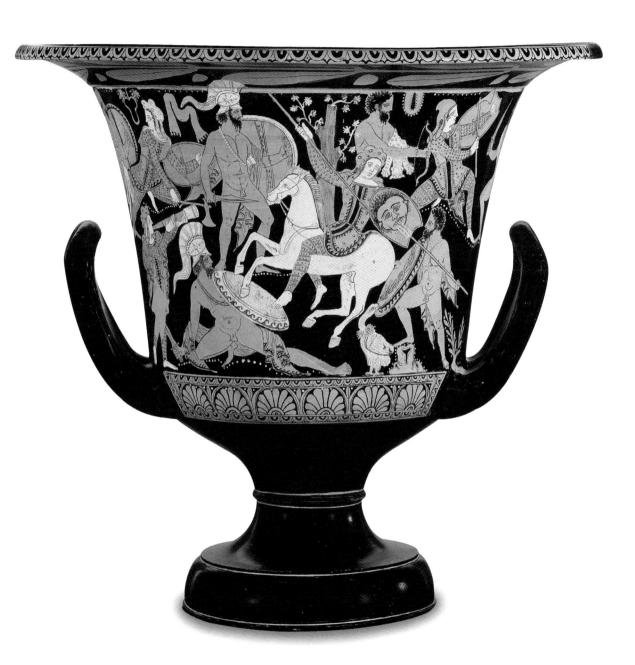

# ROMAN ART

〜〜〜〜〜〜〜〜〜〜〜〜〜〜〜〜〜〜〜

According to legend, the city of Rome was founded in 753 B.C. by Romulus, a distant descendant of a Trojan warrior who had fled to Italy and settled on the Palatine Hill near the Tiber River. Archaeological evidence also places Rome's beginnings in the first millenium B.C., but suggests that it evolved from a group of humble, isolated Latin-speaking settlements. Whatever its origins, Rome quickly gained power in the Mediterranean and by the first century A.D. ruled the ancient world from Mesopotamia to Scotland.

Both the culture and the economy of Rome were enriched by its expansion throughout Italy and abroad. The Romans so admired Greek painting and sculpture that they took much of it home to decorate their public buildings and private villas. When supply fell short of demand, they copied the originals and created new works in the "Greek style." At the same time, Roman artists (and often enslaved Greek artists) developed purely Roman styles appropriate for the narration of their history and glorification of their rulers. Roman art, like Roman society, was a mixture of widely different influences that more or less retained their own characteristics despite pressures to amalgamate.

Roman religion was much like that of the Greeks, including the depiction of gods and abstract concepts like "fortune" in human form. Like so many earlier cultures in Egypt and the Near East, the Romans came to consider their emperor a living god with absolute power throughout the Roman world.

With Rome's success at expanding its wealth and territories came the problems of ruling so large an empire. Pressure on its borders from growing hordes of non-Romans, and a faltering economy, eventually resulted in the division of the eastern and western Roman empires. Constantine, the first Christian emperor, moved the seat of government eastward to Byzantium (renamed Constantinople in his honor) in A.D. 330. The Greek-speaking eastern empire remained economically and culturally vigorous into the second millennium A.D., while the western empire fell into decline and Rome was overrun by the Visigoths in A.D. 410. Although this date is considered the official end of the Roman Empire, the achievements of Rome's engineers, generals, jurists, and writers still influence Western civilization today.

# Emperor and Citizen

One of only two remaining full-length portraits of Caligula, this statue portrays the emperor as "first citizen" of Rome, about to address his fellow Romans.

Gaius Julius Caesar Germanicus was born in A.D. 12 and reigned as emperor of Rome from 37 until his murder in 41. Great-grandson of Augustus, the first Roman emperor, Gaius earned the nickname Caligula or "baby boots" because of the little soldier's boots he wore as a child visiting his father at a Roman military camp.

In public monuments, a Roman emperor might be shown either as a citizen or as the leader of the Roman army: here, Caligula appears as "the first citizen" of Rome, wearing tunic and toga. The toga, a light wool semicircular wrap measuring about 26 square yards, could be worn only by a citizen of Roman. The clues to his high rank were his shoes and a band on the edge of his toga, both of which would have been painted red. In his left hand he once held a papyrus scroll (its storage box stands next to his left leg), and he raises his right hand (now lost) in a gesture called *ad locutio*, which signals he is about to speak.

The Roman interest in portraiture, showing the distinguishing features of individuals, has made it possible to identify this marble statue as Caligula on the basis of Roman coins bearing both his name and his portrait. We can assume that all of these portraits were somewhat idealized, in keeping with Greek sculptural traditions and the Roman political agenda of promoting its rulers. Caligula's smooth skin and ample curls (actually he was said to be bald) give him a youthful appearance balanced by his air of calm authority.

Near the end of his life, Caligula became unpopular because of his cruelty, and he was ultimately murdered. After his death, the Romans damaged or destroyed many of his statues, which may explain the fact that the head of this sculpture is separate from the body. Although the head has been recut and polished separately over the ages, studies suggest that the entire sculpture was

probably carved from one piece of marble, and the head and body belong together. Only one other statue of Gaius (at a young age), now in Gortyn, Crete, survives with its body intact.

~~~~~~~~~

Roman, A.D. 38–40
Marble; height 73 9/16 inches (186.9 cm)
Purchase, The Arthur and Margaret Glasgow Fund, 71.20

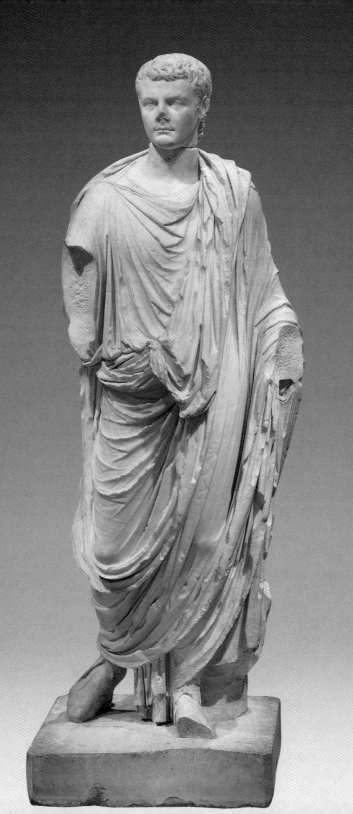

Egyptian in Theme, Roman in Spirit

Prancing with realistic elegance, this statuette of the Apis bull reflects the popularity of Egyptian art in Rome.

This bronze figurine depicts no ordinary barnyard beauty, but the Apis bull, a living animal worshipped by the ancient Egyptians at Memphis. The Apis bull was an aspect of the god Osiris, Lord of the Underworld, and represented creation, burial, and hope of rebirth. Upon its death, the actual bull was embalmed in precious oils and buried in catacombs at Saqqara, near Memphis. A new Apis bull was then chosen by the priests of the cult. The bull selected to represent the god would have to conform to twenty-nine characteristics—including a black coat, a white triangular patch on its forehead, and a mark in the form of a scarab beetle on its tongue. In keeping with the spirit and function of Egyptian art, Egyptian artists represented the Apis bull in a static pose with all four hooves on the ground and head facing forward, on the same axis with the spine. The distinguishing attribute was a sun disk between his horns.

This fine Roman statuette—with eyes of inlaid silver and a lively pose—could never be mistaken for Egyptian workmanship. From the massive head, turned to gaze directly at us, to the elegant swing of the tail, the Roman artist has captured the power and strength of a prize bull. The curly locks and prancing gait add grace and movement, typical of Roman taste. A hole on top of the head indicates where the Apis sun disk once stood. The surprise is that this statuette is not quite 5 inches tall (see gallery photo, p. 82)

Following the Romans' defeat of Cleopatra VII in 31 B.C., the Romans adopted many aspects of Egyptian religion and art. Egyptian cults and "Egyptianizing" styles of decoration became especially popular. At the Roman city of Pompeii, which was destroyed by the eruption of Mount Vesuvius in A.D. 79, preserved areas reveal that Egyptian motifs were painted on the walls in upper-class homes. Small bronze figures of the Apis bull, the Egyptian mother-goddess Isis, and Serapis (see p. 84), probably once placed in household shrines, were also found among the ruins.

Roman, 100 B.C.–A.D. 100
Leaded bronze with silver inlay; height 4 9/16 inches (11.7 cm)
Gift of the Fabergé Society, 92.1

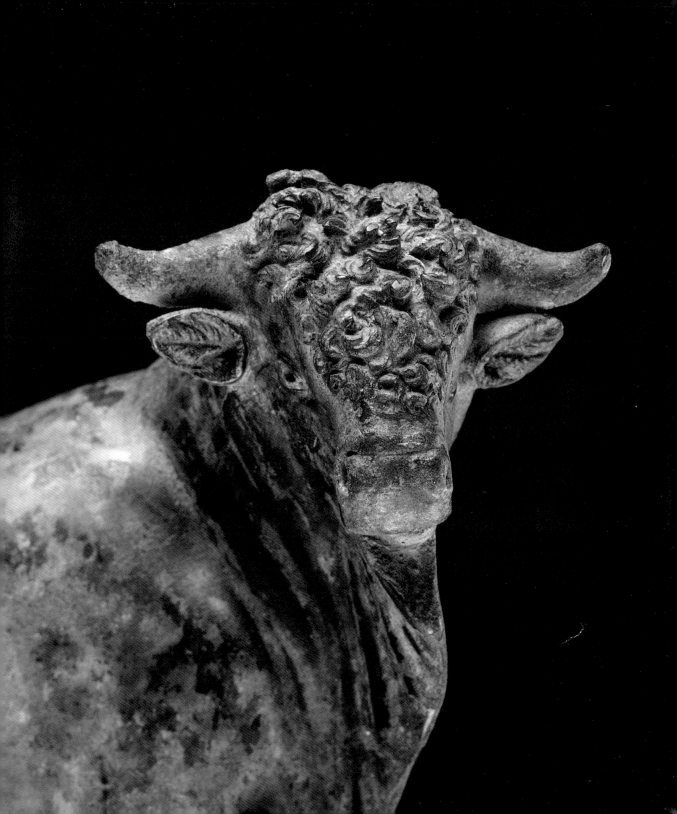

Roman "Wallpaper": Illusion and Imagination

The Romans often enlivened the walls of their villas and town houses with colorful and fantastic scenes.

Wall Painting *in the Ancient Art gallery at the Virginia Museum of Fine Arts towers over the tiny* Apis Bull *(see p. 80).*

Wall painting was a major art form in Greece, Etruria, and Rome, but natural deterioration and earthquakes have claimed all but a few examples. Ironically, many ancient murals owe their preservation to another natural disaster, the volcanic eruption of Mount Vesuvius, that occurred south of Naples in A.D. 79. Whole communities, including Pompeii, Herculaneum, Boscoreale, and Boscotrecase, were buried and preserved beneath volcanic ash until their discovery in the eighteenth century.

Preferring the privacy and security of interior courts open only to the sky, the Romans built their houses with few windows. Instead, the wealthy decorated their town houses and country villas with elaborate and colorful wall paintings, often depicting imaginary vistas. Most surviving Roman paintings were created using the fresco technique, in which tempera paint is applied onto a damp plaster surface.

This portion of a wall fresco from Room 4 in the Villa of Popidius Florus at Boscotrecase is a late example of the so-called Third Style of Pompeiian wall painting, which favors small, central landscapes framed by flat, solid colors. Fantastic architectural elements, such as the candelabrum rising from the scroll-work on top of the panel (a bird perches on one of the arms) and the flanking polychrome columns are also typical features of late Third Style wall painting. (Other walls from the same room are now in the J. Paul Getty Museum, in Malibu, California.)

On this fresco, the central panel shows a cloudless blue sky above a landscape dominated by rocky outcroppings and a tall architectural monument. In the background are trees and a long, low building. In this type of landscape, the human figure is not the focal point, merely another aspect of the composition. The quick brushstrokes of the painter add to the scene's vitality and freshness.

Roman
Late Third Style, before A.D. 79
Tempera on plaster; height 94 7/16 inches (239.9 cm)
Purchase, The Adolph D. and Wilkins C. Williams Fund, 66.35

A New God for a New World

Serapis was a powerful tool of political propaganda in the hands of both the Greeks and the Romans.

The god Serapis was a composite of Egyptian, Greek, and Roman concepts, and his origins are tightly woven into the military and political fabric of the ancient Mediterranean world.

Around 331–332 B.C., as Alexander III of Macedonia ("Alexander the Great") led his allied Greek troops eastward toward Persia, he stopped in Egypt and made offerings to the Apis bull at Memphis. To the Egyptians, the Apis bull, an aspect of the great god Osiris, signified rebirth, fertility, and regeneration (see p. 80). Because Alexander was as clever in politics as he was in military matters, he knew that by associating himself with sacrifices to an Egyptian royal deity, he would gain the Egyptians' trust and boost his own public image. In so doing, he laid the foundation for Greek rule over the Egyptians.

During the Ptolemaic Period, when Alexander's successors had risen to power in Egypt, the names and qualities of "Osiris" and "Apis" were combined to create a new Egyptian god, "Osirapis." Eventually, the name was shortened to "Sarapis" in Greek and "Serapis" in Latin.

Some time after Alexander's death in 323 B.C., the Greek rulers built a temple complex to honor Sarapis in the new city of Alexandria, named for their fallen leader. They commissioned a talented Athenian sculptor, Bryaxis, to create an image of Sarapis for the new temple. Following the Greek custom of representing gods in human form, Bryaxis made the figure of Sarapis a mature, regal-looking male, much like Zeus, Hades, or Dionysos. He was shown seated on a throne, with a panther or Cerberus, the three-headed dog of Hades, by his side.

This Roman bust of a bearded man (opposite) is readily identified as Serapis. He has on his head a *modius* (basket for measuring grain) surrounded by laurel branches to show that Egypt was a major source of grain for the Mediterranean. The eagle atop the modius is both a Greek symbol for Zeus and a Roman symbol of power. The straightforward pose, hair with bangs separated into wavy locks, and beard parted in the middle specifically identify this figure as Serapis. On this casting, eyes of inlaid silver add a touch of realism and mark it as a superior replica of the famous cult statue that once stood in Alexandria.

Serapis must have been popular among Greeks and Romans alike, perhaps more so among the Romans than among Greeks or Egyptians. During the Roman Empire (31 B.C. to A.D. 410) Serapis, along with cults of the Apis bull and Isis, became a cherished and somewhat exotic figure in Roman religion.

~~~~~~~~~~

**Roman, circa A.D. 100–200**
Bronze with silver inlay; height 14 11/16 inches (37.3 cm)
Purchase, The Arthur and Margaret Glasgow Fund, 98.23

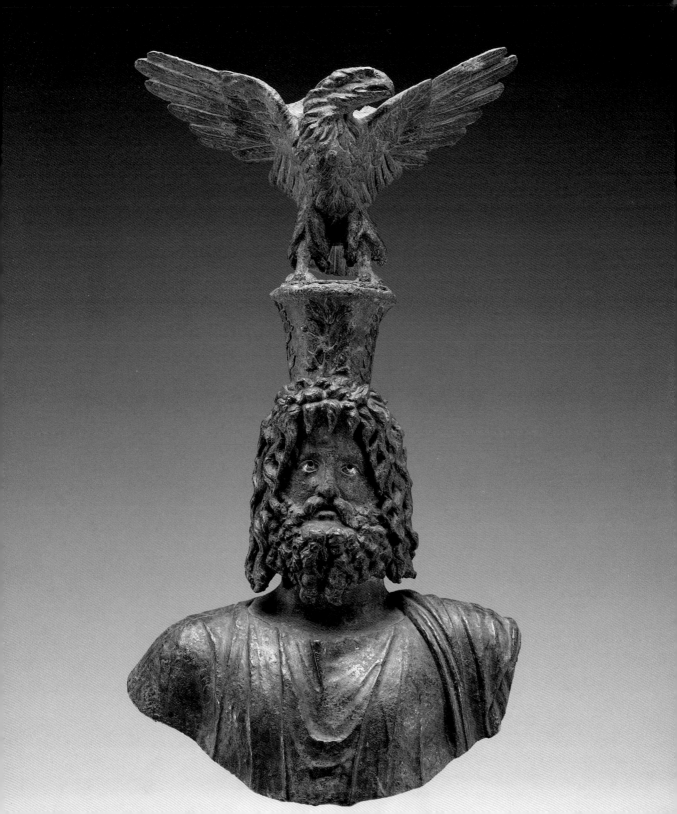

# Rhythms of Rebirth

Dancing for Dionysos could bring new life to his followers.

Memorials were an important form of expression for the Romans, and wealthy Roman families often commissioned the finest sculptors to carve them. In the second and third centuries A.D., quarries in Greece as well as Asia Minor (modern-day Turkey) dominated the marble trade. As a result, sarcophagi such as this were often the products of Greek craftsmen, using marble from Asia Minor, striving to please the latest Roman taste.

The decoration of this sarcophagus reflects Greek influence. Winged young boys, called Erotes because of their connection with Eros, the Greek god of love, are at play. Rocky outcroppings underfoot indicate landscape and place the scenes outdoors. Two Erotes (one on a side, the other on an end) imitate the Greek god Dionysos collapsing drunkenly into the arms of his comrades (a pose seen in Greek art as early as the fifth century B.C.). Others, pretending to be devotees, carry musical instruments, baskets of fruit, a torch, and a long floral garland. On the far end of the sarcophagus (not shown), three Erotes have broken away from the group to stage a wrestling contest, complete with a judge. These figures may have been carved by a different sculptor (while the master was away?). The missing lid probably was in the shape of a gabled roof, since columns were carved at each corner of the sarcophagus as "supports." This type of column, with its spiral shaft topped by acanthus leaves and a corkscrew capital, is unique to Asia Minor.

Why would a scene of revelry and drunkenness be chosen to grace a sarcophagus? Dionysos's followers celebrated his cult with wine and dancing, hoping to achieve ecstacy and "oneness" with the god, but Dionysos was also the lord of souls in the Underworld and the god of rebirth. As such, a Dionysiac scene would have carried a message of hope and consolation to the family of the deceased. The casting of this Dionysiac scene as a playful romp by children is typically Roman in that it adds layers of meaning and diverts the minds of the viewers from the sadness of death.

**Roman (Asia Minor), A.D. 100–200**
Marble; height 38 ⅜ inches (97.5 cm),
length 90 ¾ inches (230.5 cm)
Purchase, The Adolph D. and Wilkins C. Williams
Fund, 60.1

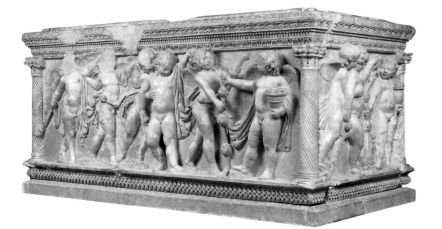

# Windows to the Afterlife

This haunting and beautiful portrait was painted to accompany a mummy.

Although the identity of this woman is forever lost, she evokes in us a sense of familiarity and sympathy. Adorned with jewelled earrings and a beaded necklace wrapped twice around her slender neck, she wears a rose-colored dress (with a hint of her white underdress at the neckline) and a mantle edged with a broad, dark stripe, all marks of a fashionable upper-class woman in Roman Egypt.

The ancient Egyptian custom of mummification continued during the Roman domination of Egypt, ending only when it was prohibited, along with all forms of non-Christian worship, by the Christian emperor Theodosius I in A.D. 391. The practice of placing a painted portrait of the deceased over the face of the mummy began during Egypt's Roman period. While these panels still met the Egyptian need to identify and preserve the appearance of the deceased, there is some evidence that portraits were made during the person's life and hung on the wall to be enjoyed until needed for the afterlife. The naturalism of the portraits, as well as the style of clothing and jewelry, reflects the influence of both Greece and Rome.

This panel was found with many others in Faiyum, a lakeside oasis west of the Nile Valley and south of Memphis. It was painted with a combination of heated wax and pigment known as encaustic, which resulted in remarkably long-lasting color. As encaustic did not permit blending of colors, the artist had to add shading and highlights with separate, carefully planned brushstrokes in colors that would add depth and detail to the woman's face and the folds of her dress. Thick applications of color and details were applied with a narrow palette knife called a *cestros*.

The subject's luminous eyes, common for this kind of portrait, at once remind the modern viewer of the age-old Egyptian emphasis on the eyes as windows to the next life.

**Roman Egypt**
**A.D. late 200s–early 300s**
Wax and pigments on wood; height 13 inches (33 cm)
Purchase, The Adolph D. and Wilkins C. Williams Fund, 55.4

# Index

**Note:** *Italicized* entries indicate works of art featured in this book.

# Suggested Reading

## GENERAL
*Ancient Art in the Virginia Museum.* Virginia Museum of Fine Arts, 1973.

Barriault, Anne. *Selections: Virginia Museum of Fine Arts.* Virginia Museum of Fine Arts, 1997.

## EGYPTIAN ART
Aldred, Cyril. *Egyptian Art.* Thames and Hudson, 1980.

Baines, John, and Jaromír Málek. *Atlas of Ancient Egypt.* Facts on File, 1980.

David, Rosalie. *Handbook to Life in Ancient Egypt.* Facts on File, 1998.

Grimal, Nicolas. *A History of Ancient Egypt.* Blackwell, 1992.

James, T. G. H., and W. V. Davies. *Egyptian Sculpture.* British Museum Publications, 1983.

Murnane, William J. *The Penguin Guide to Ancient Egypt.* Penguin Books, 1983.

Peck, William H. *Splendors of Ancient Egypt.* The Detroit Institute of Arts, 1997.

Quirke, Stephen, and Jeffrey Spencer. *The British Museum Book of Ancient Egypt.* British Museum Press, 1992.

Smith, W. Stevenson. *The Art and Architecture of Ancient Egypt.* 2nd ed. Penguin Books, 1981.

Taylor, John H. *Egypt and Nubia.* Harvard University Press, 1991.

## NEAR EAST
Amiet, Pierre. *Art of the Ancient Near East.* Harry N. Abrams, 1980.

Reade, Julian. *Assyrian Sculpture.* Harvard University Press, 1983.

Roaf, Michael. *Cultural Atlas of Mesopotamia and the Ancient Near East.* Facts on File, 1990.

Russell, J. M. *From Nineveh to New York.* Yale University Press, 1997.

## AEGEAN ART
Fitton, J. Lesley. *Cycladic Art.* Harvard University Press, 1990.

Getz-Preziosi, Pat. *Early Cycladic Art in North American Collections.* Virginia Museum of Fine Arts, 1987.

Higgins, Reynold. *Minoan and Mycenaean Art.* Rev. ed. Oxford University Press, 1981.

Karageorghis, V. *Cyprus, From the Stone Age to the Romans.* Thames and Hudson, 1982.

## GREEK ART
Boardman, John. *Athenian Black Figure Vases.* Oxford University Press, 1974, reprint 1985.

——. *Athenian Red Figure Vases. The Archaic Period.* Thames and Hudson, 1975.

Cook, R. M. *Greek Painted Pottery.* 3rd ed. Routledge, 1997.

Grimal, Pierre. *The Dictionary of Classical Mythology.* Blackwell, 1986.

Hornblower, Simon, and Anthony Spawforth. *The Oxford Classical Dictionary.* 3rd ed. Oxford University Press, 1996.

Levi, Peter. *Atlas of the Greek World.* Facts on File, 1980.

Mayo, M. E., ed. *The Art of South Italy: Vases from Magna Graecia.* Virginia Museum of Fine Arts, 1982.

Richter, G. M. A. *The Archaic Gravestones of Attica.* Phaidon, 1961.

Robertson, Martin. *A History of Greek Art.* Vols. 1 and 2. Cambridge University Press, 1975.

——. *The Art of Vase-Painting in Classical Athens.* Cambridge University Press, 1992.

Stewart, Andrew F. *Greek Sculpture: An Exploration.* 2 vols. Yale University Press, 1990.

Trendall, A. D. *Red Figure Vases of South Italy and Sicily.* Thames and Hudson, 1989.

Williams, Dyfri, and Jack Ogden. *Greek Gold: Jewelry of the Classical World.* Harry N. Abrams, 1994.

## ETRUSCAN ART
Beazley, J. D. *Etruscan Vase Painting.* Hacker Art Books, 1976.

Bonfante, Larissa, ed. *Etruscan Life and Afterlife.* Wayne State University Press, 1986.

Brendal, Otto J. *Etruscan Art.* Penguin Books, 1978.

Pallotino, Massimo. *The Etruscans.* Rev. ed. Indiana University Press, 1975.

## ROMAN ART
Anderson, Maxwell. *Pompeiian Frescoes in the Metropolitan Museum of Art.* Metropolitan Museum of Art, 1987.

Barrett, Anthony A. *Caligula: The Corruption of Power.* Yale University Press, 1990.

Boardman, John. *Oxford History of the Classical World.* Oxford University Press, 1986.

Burn, Lucilla. *The British Museum Book of Greek and Roman Art.* Thames and Hudson, 1992.

Cornell, Tim, and John Matthews. *Atlas of the Roman World.* Facts on File, 1982.

Jucker, Hans. "Caligula." *Arts in Virginia* 13, no. 2 (Winter 1973): 16-25.

Kleiner, Diana. *Roman Art.* Yale University Press, 1993.

Mau, August. *Pompeii: Its Life and Art.* Caratzas Brothers, 1982.

Peck, William H. *Mummy Portraits from Roman Egypt.* Detroit Institute of Arts, 1967.

Weitzman, Kurt, ed. *Age of Spirituality—Late Antique and Early Christian Art, Third to Seventh Century.* Metropolitan Museum of Art, 1977.

---

**Note:** Some books in this list may be out of print, but many will be available at your local library.

# Image Credits

Unless otherwise noted below, all objects reproduced in this book were photographed by Katherine Wetzel, Richmond, Virginia.

Margaret Mayo: 14, 16, 56, 58.
Ron Jennings: 50, 51, 62.
Wen Hwa Ts'ao: 20, 44.
Linda Loughran: 89.
Virginia Museum of Fine Arts staff photographers: iii, 32, 33, 54, 55, 75.

Map created in Adobe Photoshop by Kenny Kane. Water background: Uniphoto, Inc.